THEN & NOW
CONCORD

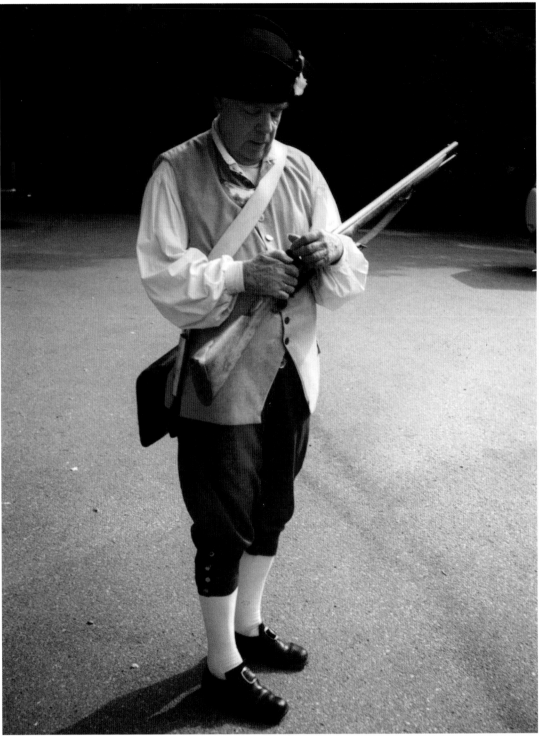

This photograph of Jack Chisholm, captain of the Minute Men, was taken in the late 1990s. Chisholm served in the fire department for 27 years and retired in 1983. His hobbies include collecting historical information and sharing with the Concord Free Public Library Special Collections Department interesting and valuable memorabilia.

THEN & NOW
CONCORD

Sarah Chapin, Claiborne Dawes, and Alice Moulton

ARCADIA
PUBLISHING

Published by Arcadia Publishing
Charleston SC, Chicago IL, Portsmouth NH, San Francisco CA

Printed in the United States of America

Library of Congress Catalog Card Number: 2001091705

For all general information contact Arcadia Publishing at:
Telephone 843-853-2070
Fax 843-853-0044
E-mail sales@arcadiapublishing.com
For customer service and orders:
Toll-Free 1-888-313-2665

Visit us on the Internet at www.arcadiapublishing.com

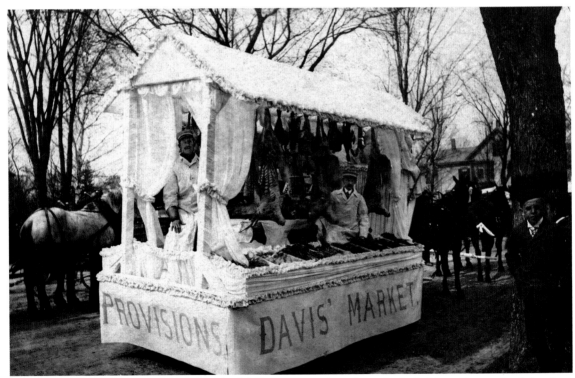

The Davis float was one of the more colorful floats ever to have been included in a Concord celebration. It represented Nathan Davis's market, located on the Mill Dam early in the 20th century. Davis's store offered rather fancy produce similar to a quality grocery store nowadays that specializes in tinned meats and exotic vegetables. The birds photographed here were ones he himself shot.

CONTENTS

ACKNOWLEDGMENTS

The authors wish to express grateful thanks to Anderson Photo, Barbara and Reed Anthony, Bette Aschaffenburg, Cliff Bean, Brad Bigham, Bill and Peggy Brace, Jack Chisholm, the Concord Art Association, the Concord Chamber of Commerce, the Concord Fire Department, Patricia Cross, Henry Dane, Charles W. Dee Sr., Katherine E. Dreier, Marie Eaton, Susan Erickson and the Thoreau School fifth grade, Mary Gail Fenn, John Finigan, Renee Garrelick, Holly and Peter Gifford, Kristen Gould, Martha Gruson, Henry Hall, Tish Hopkins, Rick Johnson, Heddie Kent, Jonathan and Judy Keyes, Fritz Kussin, Mary Lawrence, Philip James McFarland, Jim Macone, Dinnie McIntyre, Barbara Powell, Marcia Ast Rasmussen, Tom Ruggles, Melissa Saalfield, Eric Parkman Smith, Kim Smith, Sheila Spooner, Rich Stevenson, Scott Vanderhoof, Judy Walpole, Joseph Wheeler, Rachel Wheeler, Leslie Perrin Wilson, and Joyce Woodman.

The photography files in the Concord Free Public Library Special Collections Department have been made available to the authors without charge by a special arrangement with the curator, the director, and the library trustees. Proceeds from this publication will support acquisitions to the Bonnie Bracker Fund.

INTRODUCTION

Reflect how history's Changes are like the sea's.

—Richard Wilbur

Concord's history has been presented to its citizens by writers of historical essays, as well as poets, novelists, and naturalists. Artists have etched, painted, sketched, and sculpted tributes to the town's important personalities and places. Photographers coming later to the historical scene made images that have defined the early years more vividly (though more selectively) than monuments, paintings, and literature.

Lemuel Shattuck (1793–1859) printed the Act of Incorporation (1635), assuring Concord's existence in his *History of Concord* (1835): "It is ordered that there shall be a plantation att Musketaquid, and that there shall be 6 myles of land square to belonge to it . . . and the name of the place is changed and here after to be called Concord." Ralph Waldo Emerson included his former neighbors in a poem:

> Bulkeley, Hunt, Willard, Hosmer, Meriam, Flint,
> Possessed the land which rendered to their toil
> Hay, corn, roots, hemp, flax, apples, wool and wood.
> Each of these landlords walked amidst his farm,
> Saying 'Tis mine, my children's and my name's.

Essayist Henry David Thoreau wrote in *Walden* that "the vitals of the village were the grocery, the bar-room, the post-office, and the bank; and, as a necessary part of the machinery, they kept a bell, a big gun, and a fire-engine, at convenient places; and the houses were so arranged as to make the most of mankind."

Fiction writers have long depended on historical references to give their stories proper place and time. Claiborne Dawes's characters in *A Different Drummer* "climbed Brister's Hill, slowly. . . . The wagon crossed a briar field and pulled up near a small, unshingled cabin on a hill among sumach and hickories." Naturalists who visited dwindling undeveloped space year after year have noted the changes and mourned the losses caused by mankind's limited vision and narrow self-interest. In 1949, Ludlow Griscom lamented in his important study of birds in Concord that "civilization has spoiled the birding along the lower reaches of the Sudbury, most of the Assabet, and the Concord River to below Ball's Hill." Richard Eaton, in 1979, commented in *The Flora of Concord* that "the creation of the [Fairyland] pond altered the level of the water table and gradually converted the boggy meadow to an alder/red maple swamp, unsuitable for this species," causing the decline of *Potentilla fruticosa* (Shrubby Cinquefoil) collected by 19th-century naturalist E.S. Hoar.

Townspeople have benefited from remarkable local artists whose skills have refined the town's historical perception. Daniel Chester French was still a young man when he was commissioned by the town to

create the Minute Man at the North Bridge. Edward Simmons, May Alcott, and Edward W. Emerson have given Concordians the benefit of their artistic skill and observation. All have contributed to Concordians' ongoing awareness.

There has been music. Emerson wrote a hymn for the commemoration of the battle monument that was sung to "Praise God from Whom All Blessings Flow:"

> By the rude bridge that arched the flood
> Their flag to April's breeze unfurled
> Here once the embattled farmers stood
> And fired the shot heard round the world.

David Wallis Reeves wrote a march for the centennial celebration in 1875. S. Thompson Blood, a traveling vaudeville entertainer, arranged music especially for the Musketaquid Club Minstrels in the early 1900s. In 1920, Charles Ives wrote a piano sonata that he called "Concord Sonata 1840–1860."

It was the photographers, however, who possessed the most beguiling means of expression for the town's comprehension of its past. In the second half of the 19th century, when cameras were a popular fad, Alfred Hosmer (1851–1903) became an enthusiastic local photographer. Herbert W. Gleason (1855–1937) was a contemporary of Hosmer, but with a broader scope. Also, Alfred Munroe (1817–1914), Henry Castle (1869–1962), Adams Tolman (1862–1920), and Fred Alonzo Tower (1871–1959) took pictures of Concord's places, people, and events. Whatever they went out to shoot—on that day, at that moment—a part of town history was suspended in time. Many of Hosmer's photographs provide direct evidence of Concord's eclectic architectural styles in the late 1800s. Many catch his neighbors contemplating photographic immortality. Gleason's elegantly formed images, combined with Thoreau's graceful prose, opened windows of new art: nature photography.

Barbara Tuchman in *Practising History* (1981) has argued that the historian's job is to "assemble the information, make sense of it, select the essential, discard the irrelevant—above all, discard the irrelevant—and put the rest together so that it forms a developing dramatic narrative." That describes, from a somewhat different viewpoint, the very task of the photographer's discriminating eye. It is this attribute that saves historic photography (whether it is a record of the growth of a town, its people, or its natural surroundings) from being mere hindsight. Thoreau is famous for writing "Simplify, Simplify." Had he been a different kind of chronicler, he might have said with Tuchman, "Select the Essential."

The photographs in *Then & Now: Concord* represent three categories: people, places, and activities. It is the authors' hope that this book will give readers an opportunity to enjoy the continuum of past to present, as well as a chance to consider the direction of the future.

From early times in Massachusetts, a school was mandatory for every community of 50 families. Concord complied with this requirement. According to historian Dr. Edward Jarvis, the philosophy of education was rooted in more rigid disciplinary terms than in flexible intellectual inquiry. Through the years, despite differences of opinion, quality education has remained a high priority for Concord children. It remains so today.

Chapter 1

THE PEOPLE

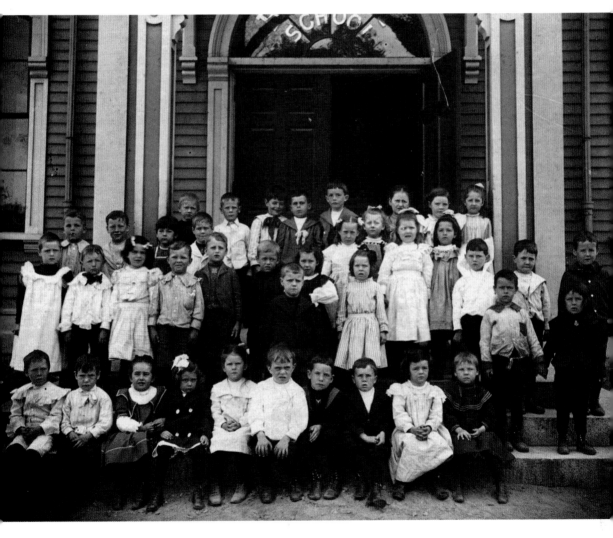

Sarah Ripley Bartlett served as library director for 34 years. She was trained at Simmons College in Boston and had been at the Concord Free Public Library while Helen Kelley was director. Edward Loughlin, and later Allen French, were early chairs of the Concord Free Public Library Committee; Charlotte Johnson and Elinor Evans were the assistant librarians. Ysobel Hutchinson was the children's librarian; after her came Marian Miller. David Little mounted important exhibitions in the gallery. Louise Stimson loaned her beautiful miniature models of *Alice in Wonderland* and Dickens's *London.* Also in these years of valuable acquisitions came the Hosmer photograph collection, Marchant's *Abraham Lincoln,* and Thoreau's survey of the Bedford Road. Barbara Powell became the ninth director, following Rosemarie Mitten in 1991.

Edward Emerson (1844–1930), son of Waldo and Lidian Emerson, was a physician, a skilled horseman, an artist and author, a valued town citizen, and in every sense of the word, a humanitarian. "He knew how to speak to a grieving soul, and recognized the right moment to bring healing." He married Annie Keyes, daughter of John Shepard Keyes, in 1874. They had seven children, six of whom died before their parents. Dr. Emerson lived on Lowell Road in the house previously owned by Arthur Fuller, a stove manufacturer in Boston. Dr. Francis McDonald, a pediatrician with offices on Main Street, cared for the children of Concord for many years. He served in the U.S. Navy and was a well-known figure at Patriot's Day parades. "Dr. Mac," as he was known, died in 1979. He is pictured below with Eben Horton, son of Sue Horton.

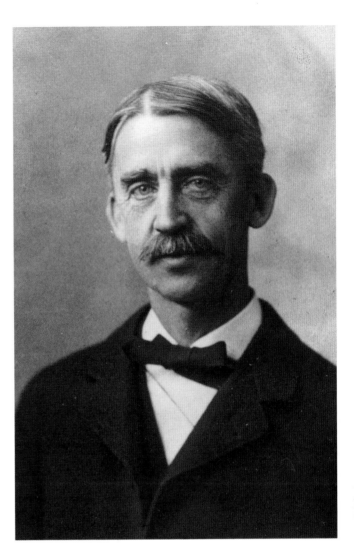

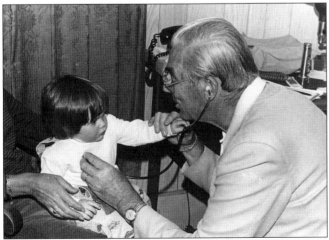

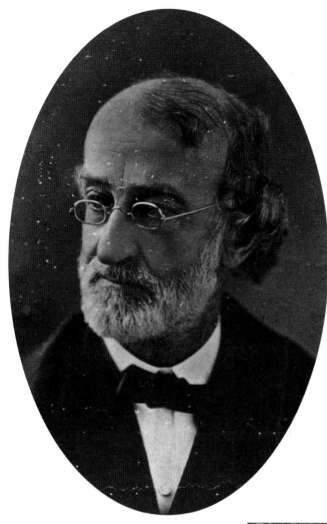

Harrison Gray Otis Blake (1816–1898), a Worcester native, was the executor of Thoreau's literary estate and one of the first great proponents of Thoreau's philosophical ideas. Although his opinions did not always coincide with other early Thoreau devotees, his efforts on behalf of Thoreau's public image were nonetheless of crucial importance. Tom Blanding was born half a century after Blake's death. A resident of Concord for more than two decades, he has protected and preserved the Thoreau legacy launched by Blake, Dr. Samuel Jones, photographer Alfred W. Hosmer, and continued by early Thoreau Society members Raymond Adams and Walter Harding. Blanding is without peer as the world authority on Thoreau's life and writings.

Alicia Keyes (1855–1924), seen below on the left, was the daughter of John Shepard Keyes and Martha Lawrence (Prescott) Keyes and sister of Annie, Florence, and Prescott. She studied art with May Alcott and Mary Wheeler and became an instructor of art at Wellesley College and a lecturer at the Museum of Fine Arts in Boston. Among her possessions in the archival collection at the Concord Free Public Library is her gold thimble. Marjorie Whitmarsh Young, a Vassar graduate, has studied art at the DeCordova Museum and in Europe, Mexico, Greece, and Russia. She has taught locally for more than 30 years. Pictured with her are longtime friend Beverly Bringle, student Kristin Lawson, and Helen Johnson.

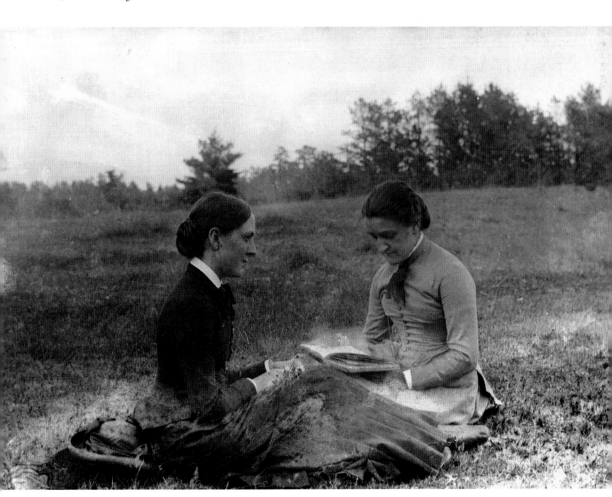

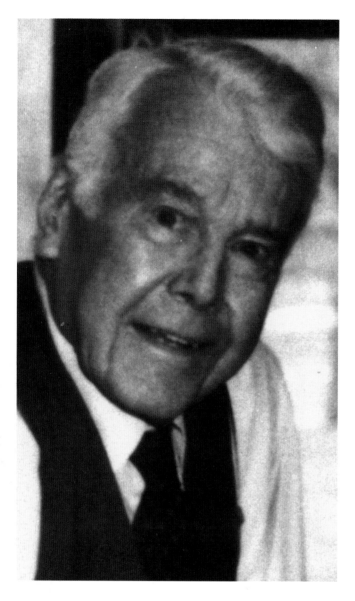

Richard Jefferson Eaton (1890–1976) was a native Concordian whose lifelong interest in the town's botanical resources paralleled that of earlier botanists Jarvis, Thoreau, E.S. Hoar, and Hosmer. He published *The Flora of Concord* in 1974. Peter Alden was educated in Concord and the University of Arizona. The author of 14 nature books, he organized the first 1,000+ Species Biodiversity Day on July 4, 1998, in Concord. The 1,905 species "above the size of a chigger" were identified in one day by more than 100 professional and amateur naturalists, who gathered to share their expertise and enthusiasm for all the plant and animal life—everything that grows, walks, flies, crawls, and swims in the Concord area.

An article in *Reader's Digest* (September 1977) called Vanderhoof's Hardware store "Hardware U—The Great American Learning Center." In 1904, Albert Vanderhoof gave up his job in Boston, came to Concord, and bought the hardware store owned by M.L. Hatch, a couple of stores east of Frank Pierce's shoe store. Vanderhoof always knew the right hardware for the job and patiently explained its proper use. Pictured here is Philip Vanderhoof (left), Jim Finan (center), and Parker, who inherited the business from Philip (Albert's son). The business is still in the family, managed by Parker's son Scott (above, left).

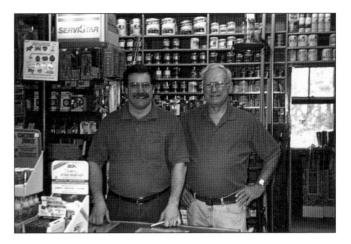

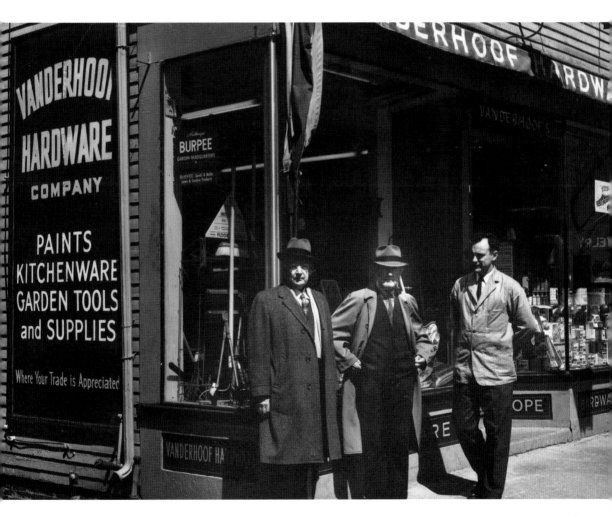

After graduating from Williams College in 1854, Henry M. Grout came to Concord in 1872 as an interim pastor of the Trinitarian Church and remained 14 years. He was given an annual salary of $1,600 (later raised to $2,000, but almost immediately reduced because of the church's financial reversals). He was "a man of great social warmth, a lover of books, and an effective preacher." He died in 1886 in Boston. Katrina Wuensch came to the Trinitarian Church in 2000. She is a native Concordian and was educated at Concord High School, the University of Pennsylvania, and the Oberlin and Harvard Divinity School. She is the associate minister.

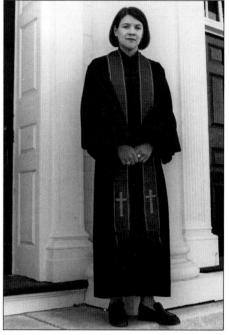

The Dee family has been in Concord and has served the townspeople as funeral directors for four generations. The business grew out of an association with Willard T. Farrar, the first "burial agent" (1868). The Dees and the Farrars worked together until William T. Farrar's death in 1910. The town laid out the avenues and exhorted the townspeople to plant trees in Sleepy Hollow; the Dees kept the burial records. The people in the old photograph are, from left to right, Mary (Davis) Farrar, her daughter Sarah (m. George Hopkins in 1871), and Willard T. Farrar. The present Dee family members on the porch are, from left to right, Susan M., Dari L., Blayne E., and Charles W. Jr.

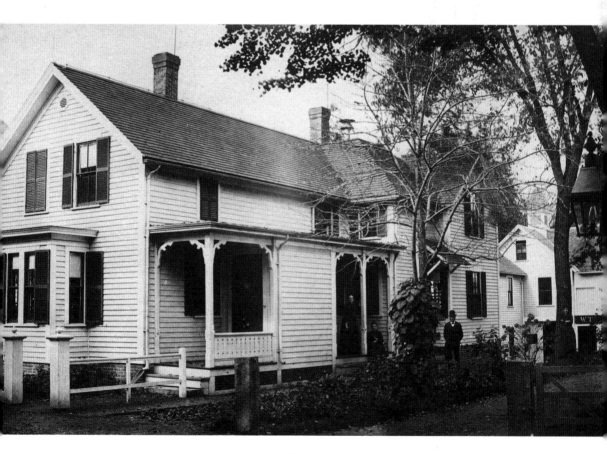

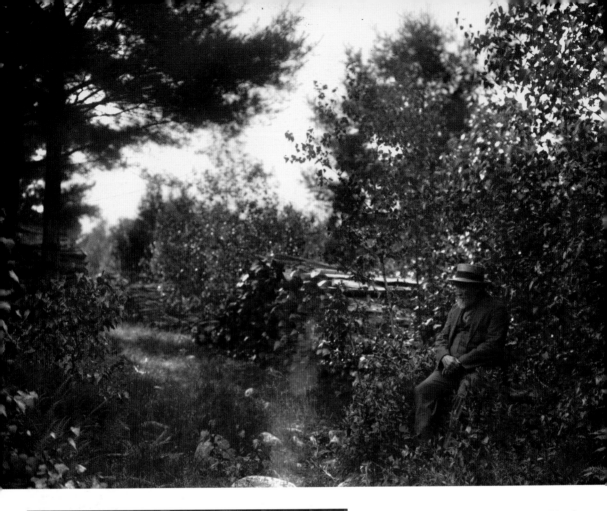

Frederick G. Pratt, the first child of Minot and Marie Pratt, was born in 1831. Their marriage ceremony was the first one performed by Ralph Waldo Emerson. Fred was the only Concordian to be drafted in the Civil War. After the war, he became a nurseryman (the Concord Nursery, not to be confused with the school). Fritz Kussin's mother was Louisa Alcott Pratt (b. 1900). She started the Children's Shop in 1938. The toy section of the original store became the Toy Shop; the clothes section is called Kussin's and is owned and operated by Fritz and his wife, Gigi, the bookkeeper and window designer. He is shown here with grandchildren Bronson Alcott, William, and Gabriel.

Herbert Wendell Gleason (1855–1937) took photographs of the landscape around Concord to illustrate the Manuscript and Walden Editions of Thoreau's writings. Thoreauvian Raymond Adams said, "There has never been another such superb piece of illustrating in the history of publishing the classic pieces of our literature." Ivan Massar came to Concord in the 1960s. His images of the Thoreauvian countryside, taken half a century after Gleason's, reflect the same genius as his predecessor. Both Gleason and Massar are known also for dramatic images made in other parts of the country. This portrait of Ivan Massar was taken by a photographer friend, Bill Anderson.

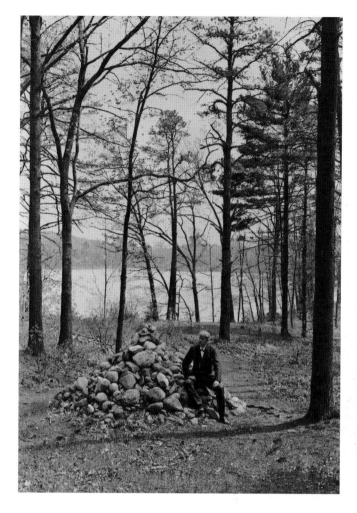

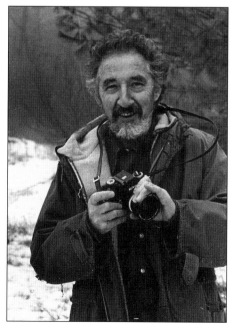

Edith Emerson Forbes was born on November 22, 1841, two years after Ellen and three years before Edward. Her mother wrote after her birth, "The baby increases in all perfections. We all—indeed all who see her think her very pretty. . . . We have not decided upon a name. . . . If I had my choice the name should be Lucy Cotton for our Mother—but Mr. E does not fancy it—and so I give it up." Edith married William Forbes in October 1865. He served in the Civil War and saw General Lee surrender at Appomattox. Edith had eight children. She died in 1929, one year before her brother Edward. Her grandson David Emerson (1916–1998) and his wife, Mary (Sitta) Cochran, were Concord Citizens of the Year in 1985. He was co-founder of the Concord Land Conservation Trust and served on the town planning board and on the finance and school committees. Mary (Sitta), his wife, survives him.

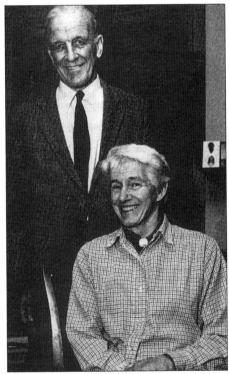

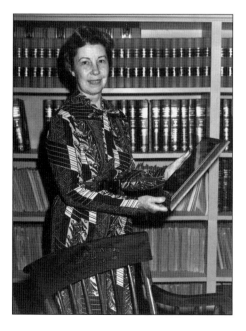

L ouisa May Alcott's involvement in Concord's political concerns is often overshadowed by her literary successes. In 1882, she declared that Concord "seems to be content with the reflected glory of dead forefathers and imported geniuses, and falls far behind smaller but more wide awake towns." She went on to say, "Well-to-do and intelligent women . . . only need a little training, courage, and good leadership to take a helpful and proper share in town affairs." Annabelle Shepherd moved to Concord in 1969. She became a selectman in 1980 and served until 1986. Besides the Concord Board of Selectmen, she also served on the FinCom, the Concord Board of Assessors, and the Hugh Cargill Fund for Silent Poor. Later, she became a trustee and then the first woman chairman of the trustees of the Concord Free Public Library.

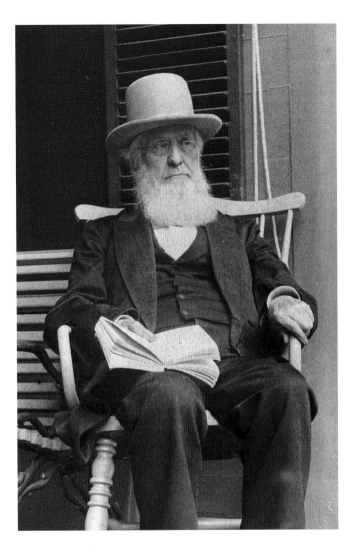

E benezer Rockwood Hoar (1816–1895) was a state senator, attorney general of the United States, and a member of the House of Representatives. According to a tribute made by the Massachusetts Historical Society, he was "shrewd in thought, keen of speech . . . whenever and however it was struck, the material of which he was made returned a true ring." Those words also apply to Richard Goodwin, a Harvard Law School graduate, law clerk to Felix Frankfurter, and an assistant to John Kennedy when he was a senator. Goodwin later became deputy assistant secretary of state for inter-American affairs and created the Alliance for Progress for Kennedy and the Great Society for Johnson.

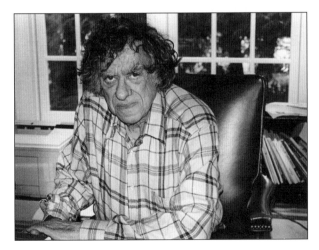

D oris Kearns Goodwin (below) won the Pulitzer Prize in history in 1995 for *No Ordinary Time: Franklin and Eleanor Roosevelt: The Home Front in World War II.* She has also written important books about the Kennedys and Lyndon Johnson. In her books and commentaries on National Public Radio, she has raised significantly the national standards of political analysis. Elizabeth Palmer Peabody (1804–1894) believed in the individual "as both an integral part of history and [as] being capable of intuitively understanding the political and social currents of the past as well as the present." Local authority Leslie Perrin Wilson refers to Peabody's grasp of history as encyclopedic. The designation is equally applicable to Goodwin.

In 1872, a "discreditable fracas" (a racial incident) caused the town to appoint its first bona fide policeman, Edwin Smith. Before that there had been "sundry persons" engaged to maintain order during events involving crowds or rebellious dissidents. The policeman's job was, and still is, to keep the peace for the general good of the community. Even though Concordians are familiar with the night Thoreau spent in jail, it was not a police officer who put him there; it was Sam Staples, the deputy sheriff. The constable, until 1789, was a prominent citizen whose task was to collect taxes. Nowadays, the sheriff is an elected officer. He has police powers. A constable is appointed by the selectmen. Leonard Wetherbee is both chief of police and a constable. He is shown below with his father, who served on the force for 23 years.

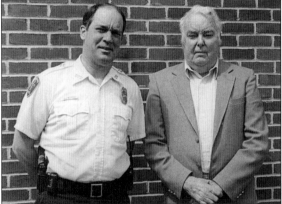

By 1919, all of the Concord Fire Department's horse-drawn fire apparatus had been replaced with motorized vehicles. The firemen below are on the American LaFrance motor truck at the fire station on Walden Street (now the Walden Grill, the Salon Arte II, and the Open Market). Current firefighters are shown at the fire station that was built in 1959 farther down on Walden Street. They are Brian Lefebvre, Jay Redmond, Sean Murphy, and Capt. Mark Cotreau. The truck is a 1990 E One Cyclone (1,500 gpm pump). In 2000, there were 4,374 calls for all services. In 1936, there were 105 calls: 27 box alarms, 55 grass fires, 13 chimney fires, and 10 automobile fires.

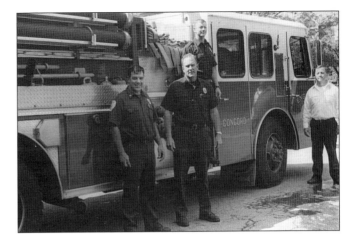

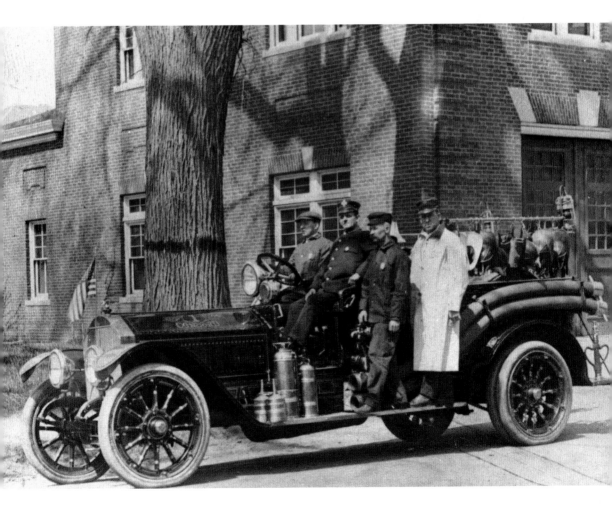

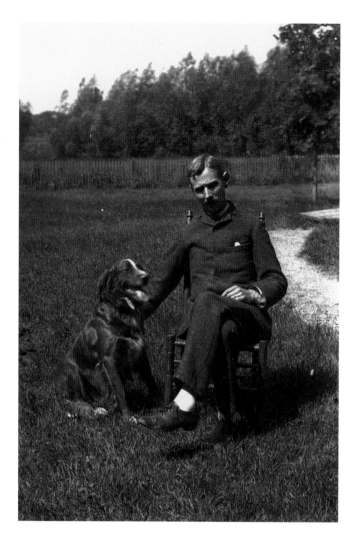

Alfred (Fred) Hosmer (1851–1903) took many photographs in this collection. This image is taken from a set of animal pictures (mainly cats and dogs) that Hosmer made as he experimented with different lights and shade in outdoor work. He understood and shared, with particular sensitivity, Concordians' fondness for dogs. The town's beloved veterinarian, Dr. Edgar (Brud) Tucker, who came to Concord in 1941 to assist Dr. Alden Russell, was one of Concord's most treasured citizens. A tender, sympathetic, and wise caregiver, Brud Tucker in a real sense gave his life to Concord's creatures. He died in 1994. His wife, Virginia (Jinny, née Joslin), survives him.

The most famous and most prolific author of children's stories in Concord is Louisa May Alcott (1832–1888). Of the many books that she wrote, *Little Women* (1867) is unquestionably the favorite. It was followed by *Little Men* (1871) and *Jo's Boys* (1886), with many others in between. Nancy Bond, another celebrated Concord author, has written eight books, among them Newbery honor book *A String in the Harp* (1976), *The Best of Enemies* (1978), *Country of Broken Stone* (1980), and *The Love of Friends* (1997). Each of these women writers draws readers into familiar situations, some happy, some sad, which are part of all children's living experience and all adults' special memories.

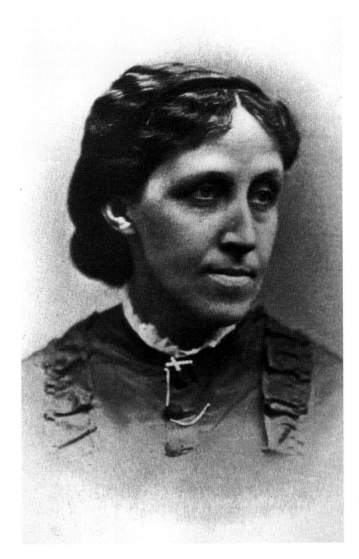

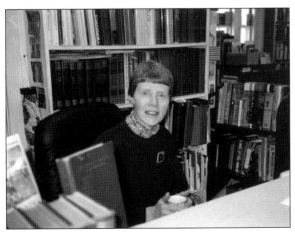

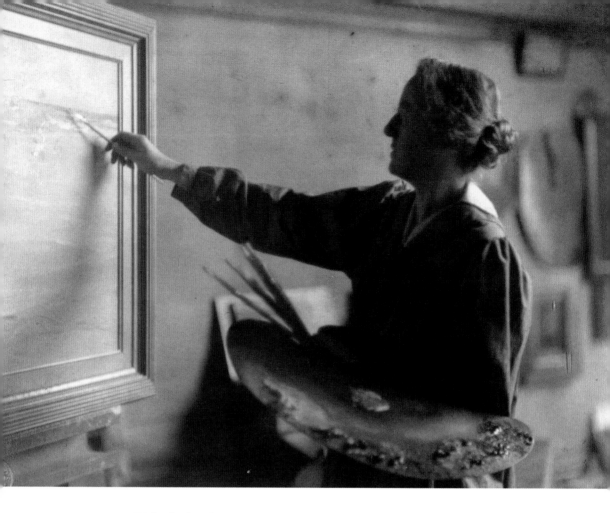

Elizabeth (Elsie) Wentworth Roberts (1871–1927)—founder of the Concord Art Association and the artist who painted *Memories of Antietam,* which hangs in the big meeting room on the second floor of the Concord Town House—bought the Jonathan Ball house from Lawrence Park in 1922. She renovated it for gallery purposes and mounted an exhibition of stunning versatility and talent—works from Cecelia Beaux, Mary Cassatt, Childe Hassam, Rockwell Kent, Claude Monet, John Singer Sargent, Daniel Chester French, and Alexander Singer Calder. Mary Ogden Abbott, granddaughter of Charles Francis Adams, was president of the Concord Art Association from 1942 until 1971. Her carved teak doors were hung at the U.S. Department of Interior in Washington and at the Peabody Museum in Salem. She is pictured here on her beloved horse Popeye.

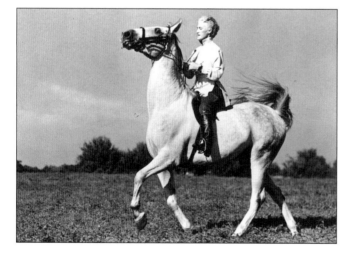

The first American Buttrick ancestor, William, came from England with Rev. Peter Bulkeley on the *Susan & Ellen* in 1635. There have been Buttricks in Concord ever since. Stedman Buttrick was born on October 22, 1864. He married Olive Bagley in 1896. They had five children: Helen, Stedman, Olive, John, and Mary. Stedman Buttrick served the town as town auditor, selectman, and as a member of the Concord School Committee. He died in August 1925. The present Stedman Buttrick, grandson of the aforementioned, has followed his grandfather as a contributor to town affairs. He has been a trustee of the Concord Free Public Library for 35 years.

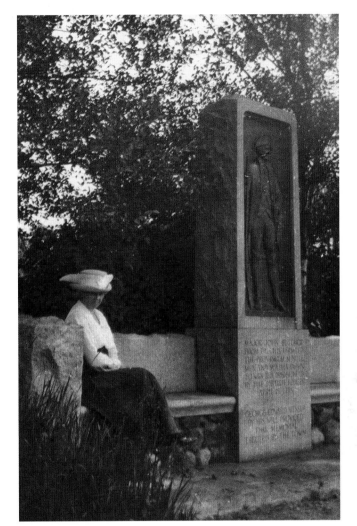

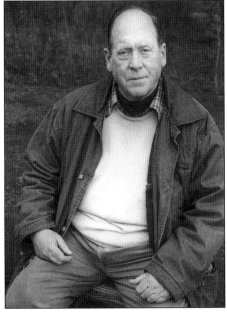

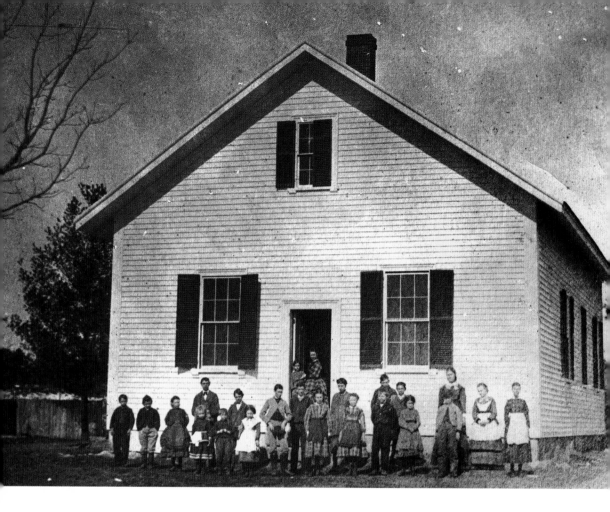

Regarding education in New England, Gertrude Stein commented, "In New England they have done it they do do it they will do it and they do it in every way in which education can be thought about." Concord's methods, therefore, may be said to conform to normal educative practices. The District 6 school, in 1864, was in "good repute . . . presenting those traits of graceful behavior and ready scholarship that have characterized it before." There were too few students to justify keeping the school open 20 years later. During 2000, the Thoreau School fifth-grade class (Susan Erickson, teacher), using economical computer technology, the resources of the Concord Free Public Library, and interviews with local citizens, created a color film depicting past and present history of West Concord and the Assabet River. The film was first shown to the public on December 19, 2000.

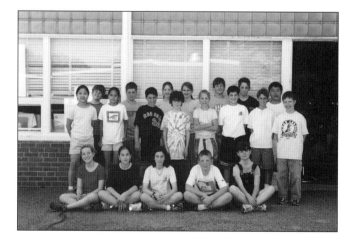

A child with a doll could be a pleasant model for photographer Fred Hosmer. He experimented with portraits throughout his photographic career and seemed especially interested in posing his subjects outside, where the light was bright and the shadows distinct. Although it was more lucrative to make images of Concord's noteworthy citizens, Hosmer often photographed children, supporting the hypothesis that it was the art of photography that engaged his interest at least as much as the prospect of profit. Children with dolls and baby carriages come to the annual Fourth of July Picnic in the Park at Emerson Playground; they often dress up, decorate their doll carriages, and in every way enjoy the summer festival.

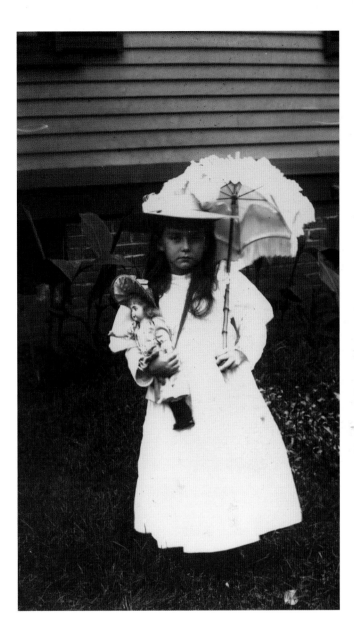

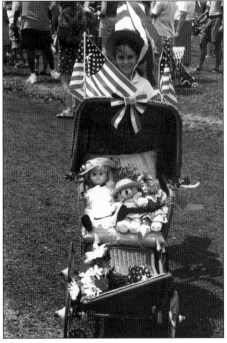

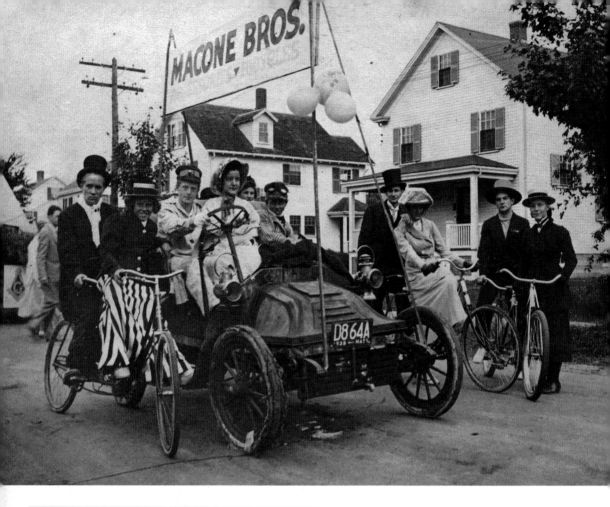

Nicholas Macone was the owner of Macone Brothers automobile agency on Lowell Road in 1910, with his five brothers: Rube, Frank, Joe, John, and Augie. They acquired the Maxwell-Chalmers agency in 1915 and became one of the first Chrysler dealers in the area. Later, they sold outboard motors to hunters and fishermen with whom they shared enthusiasm for outdoor sports. Fun-loving and hardworking, two Macone brothers, Ralph ("Peanut") and Joe, repaired bicycles and sold sporting goods and toys in the old garage in recent years. In the next generation, Jim Macone, who inherited his relatives' interest in the out-of-doors, has continued his family's reputation for quality service as a contractor.

Col. Cyrus H. Cook (1865–1914) was buried at Sleepy Hollow with full military honors, including a three-volley graveside salute fired by the 3rd Battalion, which he commanded. His funeral cortege included delegations from the U.S. Customs House, where he had been inspector; the Spanish-American War veterans; the Corinthian Lodge of Ancient Free and Accepted Masons; and the Massachusetts Legislature Committee on Military Affairs. His first association with the 6th Regiment was in 1883 when he joined Company I as a musician. He was 18. Gen. Otis Whitney was the commanding general of the 26th Yankee Infantry Division. He began his military career as a private in the Massachusetts National Guard, of which he said in his Harvard

Class Report in 1980, "My first love throughout the years has been the Massachusetts National Guard." After the war, he served in the state legislature and as a justice in the Court of Central Middlesex. He died in 1982 at age 73.

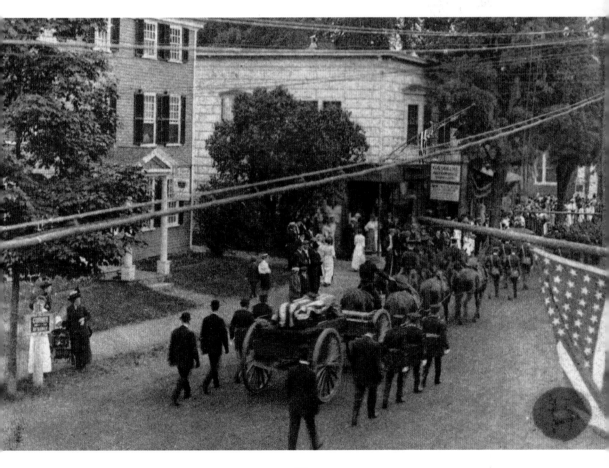

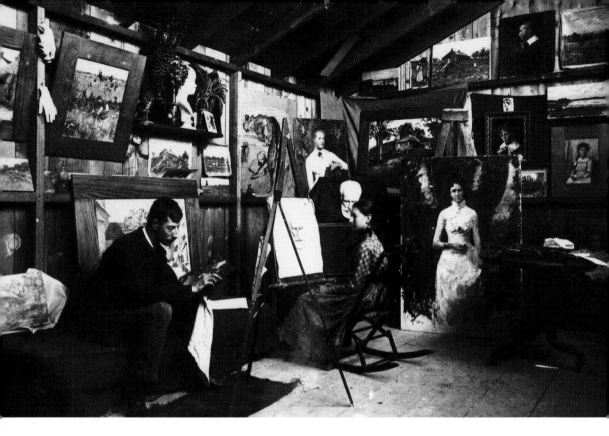

L oring Coleman (left) graduated from Middlesex School in 1938 and taught art and art history there from 1948 until 1974. Of his work he has said, "My paintings . . . are basically abstract. My concern is to say what I have to say by means of the best design I can put together. . . . The end result hopefully expresses my feelings about a specific subject without in fact making a literal copy of what I have seen." Early in his career, Stacy Tolman (1860–1935) shared a studio with the eminent sculptor E.C. Potter. He studied at the Museum of Fine Arts and in Paris and taught at the Rhode Island School of Design and MIT. The Concord Free Public Library owns a number of Tolman's portraits in addition to three river landscapes.

Sophia Thoreau (1819–1876), the fourth Thoreau child, shared her brother's love of nature. She learned the places where the shy wild flowers grew and visited them with Henry, much as neighbors might drop in to see their friends. She made a fine collection of the local flora now part of the collection of the Thoreau Society. Mary Walker is well known as a Concord naturalist and Thoreauvian. A longtime member of the New England Botanical Club, she created the botanical collection formerly at the Harvard Field Station in Bedford and has been influential in the development of the library at the New England Wild Flower Society (Garden in the Woods) in Framingham.

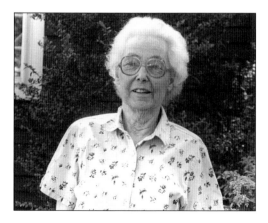

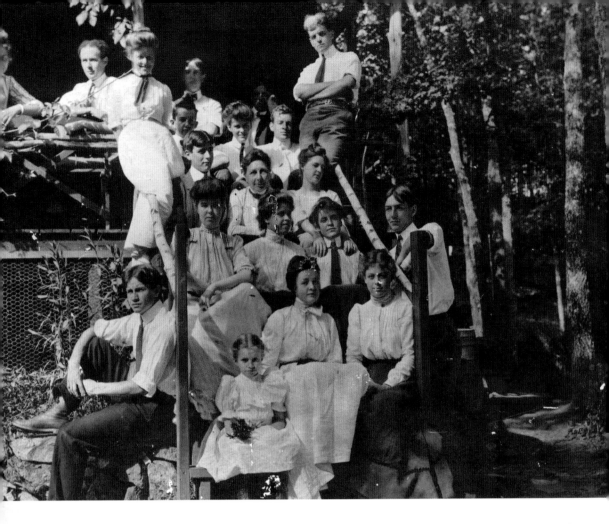

The Social Circle memoir of Sam Staples, written by John S. Keyes, states that Staples was "quite the factotum of the town and was one of its most obliging and useful citizens, acting as adviser, referee, appraiser, guardian, commissioner, and in other capacities." Ralph Waldo Emerson officiated at his marriage to Lucinda Wesson, and Bronson Alcott was one of only two guests. Staples was clever, resourceful, and fair-minded. At some unspecified time, he bought the land on the banks of Fairhaven Bay and built a house there. It is this place where young people gathered for parties in the early 1900s and where Ruth Wheeler lived and died. It is still occupied by Wheeler family members. Dr. Rachel Wheeler is shown on the steps.

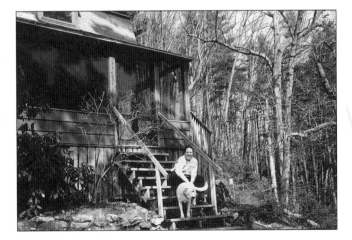

Main Street, shown in a view looking west, is remarkable for the width of the roadway. It was broadened to 66 feet in 1872, some said to improve the vista through town to the newly constructed library. Indeed, it was William Monroe, the library's donor, who first suggested the expansion, but the distance between the stores made plenty of room to tether the horses safely and, later, to maneuver the growing number of automobiles and trucks.

Chapter 2

THE PLACES

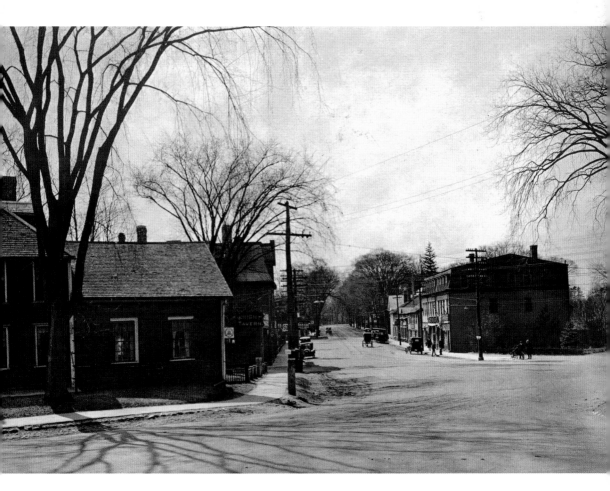

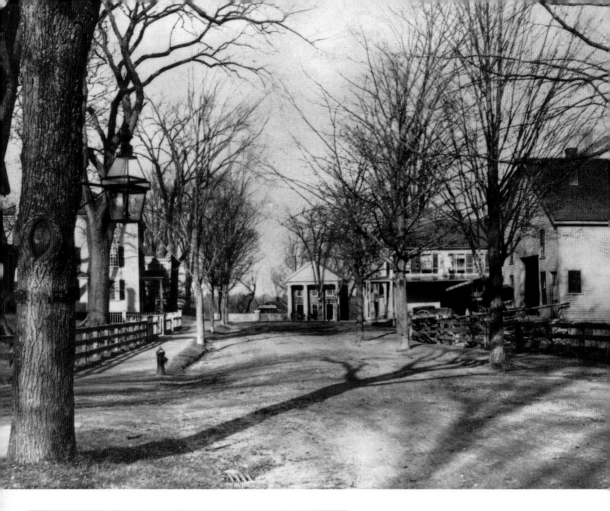

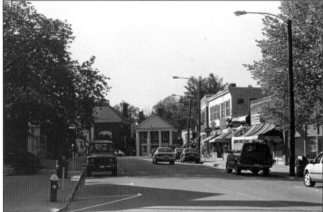

The building in the center of the photograph was once the location of the Concord bank, incorporated in 1832 and reorganized in 1865 as the Concord National Bank. Significant names associated with it are Daniel Shattuck (brother of Lemuel Shattuck, author of *History of Concord*), John M. Cheney (the cashier), and Henry J. Walcott. Now there are four banks in Concord center, and the charming old building is a shoe store. The stores on Walden Street have changed over the years, as the town has grown less agricultural and more urban. Stores have replaced houses; haberdasheries have become real estate agencies; and grocery stores are now ladies' clothing stores.

In 1891, before leaving Concord to live in New York City, William M. Prichard, son of Moses Prichard, donated $3,000 for the construction of wrought-iron gates to be built at the entrance of the Sleepy Hollow Cemetery. The masonry was buff brick with sandstone trimmings. The gates were removed in 1947. Now most of the gates are kept closed except for the most traveled route through the cemetery to the Author's Ridge. One-way signs direct the traffic to a parking space at the foot of the ridge on which the famous authors are buried. The Prichard gates are now at the Woodlawn Cemetery in Acton.

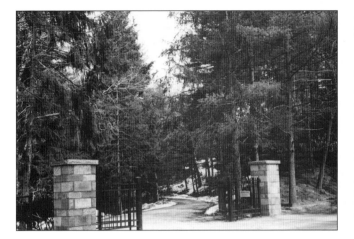

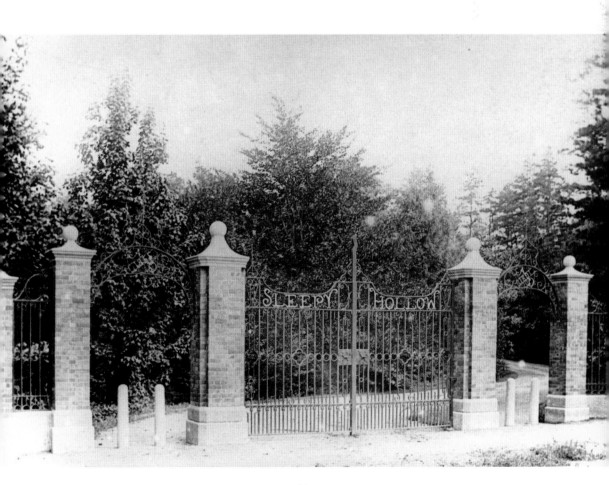

Hutchins Farm is so named for Charles Hutchins, who bought the property from Peverill Meigs in 1887. Owners previous to Meigs were John B. Tileson (his wife, Mary, wrote *Daily Strength for Daily Needs,* a favorite of Ellen Emerson), Edward Hornblower, and three generations of Nathan Barretts. The first Nathan received the acreage from his father, Col. James Barrett; the second Nathan was the first farmer to grow apples for eating instead of cider making; and the third Nathan increased the size of the farm to 500 acres. Dairy farming lasted into the 20th century. Now the acres on the south side of Monument Street are used for raising and selling organic vegetables.

Elizabeth and Emma Williams, children of John D.W. and Ellen (Bigelow) Williams, built a house in 1899 ("a home of boundless hospitality and charm") that would easily rival a Concord mansion design of today. The land was originally farmland belonging to Woodis and Isaac Lee. Richard Fessenden bought the property from Emma Williams in 1925. She died in 1928 at age 88. Her sister Elizabeth died in 1916 at age 79. Woodis Lee was the son of Joseph Lee, who married three times, each time to a woman named Mary. Joseph inherited the Simon Willard farm from the first Mary, who inherited it from her father.

The Benson property, recently identified as the town's newest source of water, lies on one of Concord's oldest roads, laid out in 1747. Previously called Benson Road, it was changed to Balls Hill Road in March 1952. The old Benson homestead is to be dismantled and rebuilt elsewhere to accommodate the well construction. The path dividing the house lot from the barn has long been a pathway down through the extensive marshland to the river. It will now provide access to the well area and possibly a residential development. All the woods, fields, and swamps were William Brewster's special "Concord River" neighborhood where he studied birds and small animals.

This handsome house was built in the 1870s by G.F. Geer, one of the many express agents in Boston. When he found himself in straitened circumstances, the house was auctioned to pay the bills. John Chapman, Concord's prominent architect, bought it and lived there until 1893, when he moved to Virginia. It was then purchased by Charles Edgarton. Among John Chapman's commissions were the 1886 West Concord School, the 1888 Concord High School (where the Emerson Umbrella parking lot is), the well house at the Nashawtuc Hill reservoir site, and the Trinity Church chapel. Chapman married Lucy Barrett, daughter of Jonathan Fay Barrett in 1876. He died in 1895.

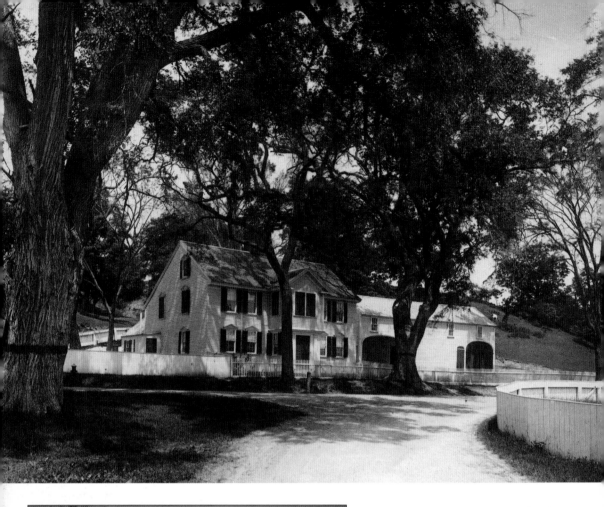

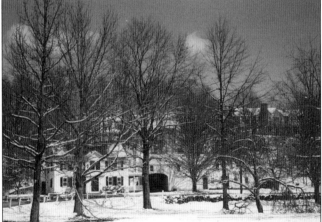

The Heywood House is a familiar landmark for modern commuters who turn onto Lexington Road from Heywood Street (earlier called Potter's Lane or Ford Lane). John Brown built the present house in 1719. It came into the Heywood family in 1822, when Dr. Abiel Heywood, whose task it was to call the banns, startled the town by announcing his own intention to marry Lucy Fay after years of celibacy. He was simultaneously the town clerk and chairman of the board of selectmen for 38 years and assessor from 1796 to 1826. Additionally, he was a founder of the Middlesex Mutual Fire Insurance Company. His son George was the town clerk for 40 years; his great-uncle and great-grandfather also served as town clerk, so that position was filled by Heywoods for 164 years.

The Block House was next to the burying ground on Main Street until the 1930s, when it was purchased by the Middlesex Bank and moved across the fields to its present location on Lowell Road. In 1676, it was one of the garrison houses (others were at Meriam's Corner; at a site near the present Emerson Hospital; at the Flints, close to the North Bridge; and at the Nine Acre Corner). In the earliest years of the town, there were no such refuges built to protect the townspeople because, in those early days, there was no fear of Native Americans. The Block House owners have included Jonathan Prescott, Henry Prescott, Dr. Isaac Hurd, Dr. Henry Barrett, Anna Holland, and Alden French. It is now privately owned.

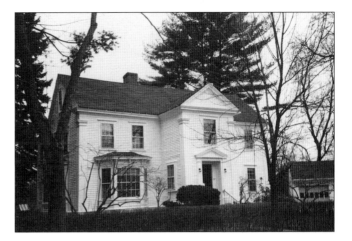

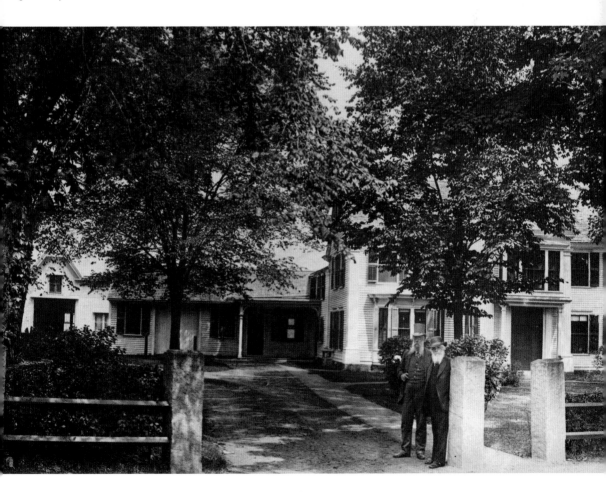

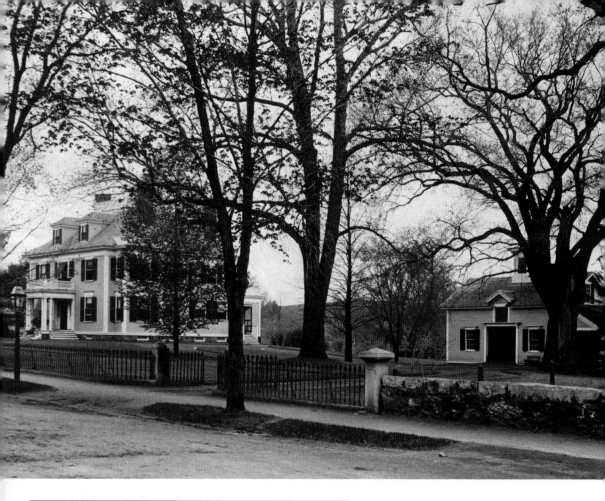

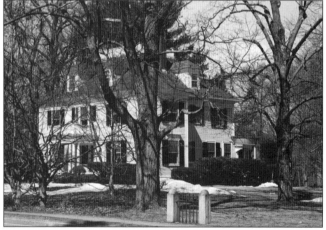

The Woodward Hudson house, on Main Street, is the second of the two houses on that lot owned by Hudsons. Frederic Hudson, editor of the old *New York Herald* and co-founder of the Associated Press, bought the land and house thereon in 1866. Woodward Hudson, son of Frederic, born in 1858, moved that house to Thoreau Street and built a new one in its place, in which he lived and where he died in August 1938. Woodward Hudson was a railroad lawyer. He served on the Concord School Committee, the Concord Free Public Library Board of Trustees, and as one of the Trustees of Town Donations; he was a sewer commissioner and selectman. His daughter Marion was married to Wesley Wilmot. She died in 1989, and Wes Wilmot died in 2001.

The Old Road to Nine Acre Corner, according to Ruth R. Wheeler, was created to reach "the southern part of the town [to] a nine acre plot originally the property of the Rev. Peter Bulkeley. The road to the river meadow land was called the Way to the Nine Acres, evolving later into Nine Acre Corner." The men who worked the farms to which the road led were described by Ralph Waldo Emerson: "We shall never see Cyrus Hubbard or Ephraim Wheeler or Grass-and-Oats and Oats-and-Grass old Barrett or Hosmer, in the next generation. These old Saxons have the look of pine-trees and apple-trees."

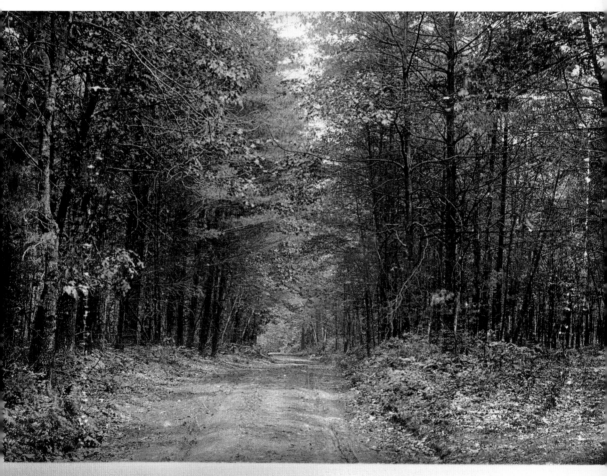

Old Road to Nine Acre Corner.

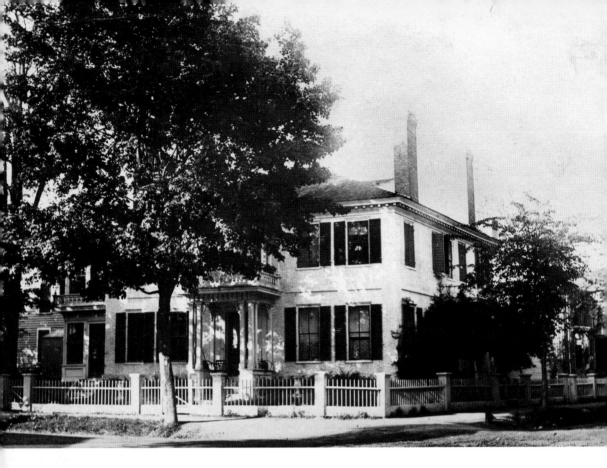

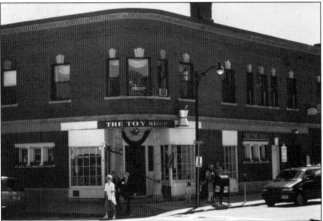

The Hastings house, at the corner of Walden and Main Streets (site of the present Toy Store, owned by David Hesel) was in 1871, as well as now, the center of Concord. It was described as "the narrow passage connecting the two globes of an hour glass." A study showed that one-day November traffic from 6 A.M. to 9 P.M. was 2,418 passengers, 95 two-wheeled and 558 four-wheeled vehicles. "Thus, five more persons than the actual population of the town passed the Hastings' corner in that brief space of time." For many years, Snow's Pharmacy was on that corner. It closed in 1998. Now the Toy Store has expanded into that space.

In 1860, the property on the far end of Lexington Road was a flourishing farm. With changes of ownership, economic security, and the vagaries of time, the farm dwindled in size and prosperity. In the mid-1880s, the large barn was erected, and additions were made to the house, increasing considerably the value of the property. About the time of World War I, the land was converted for use as a nursery known as the Paul Revere Farm. The barn burned in the 1930s. Its massive foundation is visible near the intersection of the Route 2 connector with Route 2A and Brook Road. The entire property was sold to the Minute Man National Historical Park in 1962 and has undergone extensive restoration. Owners of this property have been Job

Brooks, Charles Sawyer, Rufus and Daniel Brown, Arthur Wilson, William Goodell, Louise Leonard, Harold and Flora Keizer, and Reed and Theodore Beharrell.

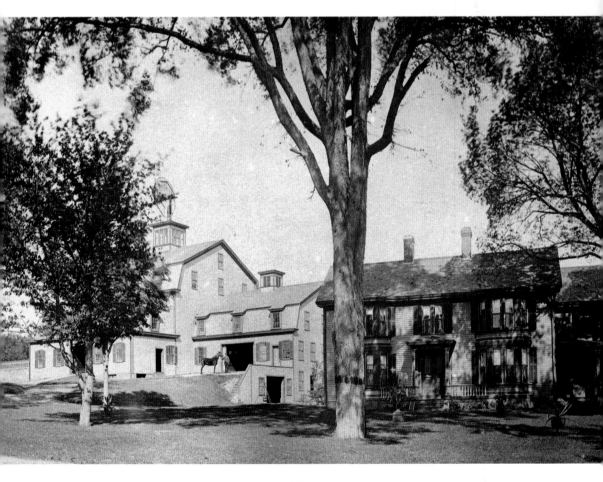

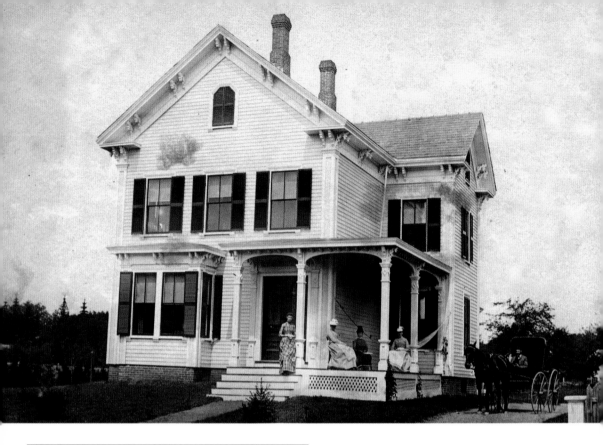

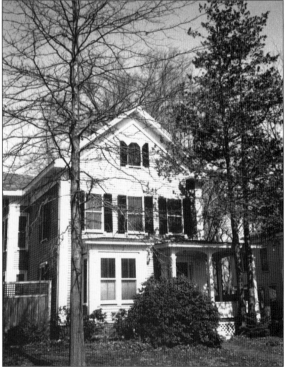

The Hubbard Street real estate development was subsidized by an impressive group of prominent Concordians, among them Ebenezer Rockwood Hoar, George Keyes, Frederic Hudson, and George M. Brooks. Thirty-seven acres originally owned by Ebenezer Hubbard were auctioned off by Sam Staples (who among his other business pastimes was something of a real estate developer). In the mid-1870s, 60 Hubbard Street was built on one of William Hurd's lots for George Messer. Its first tenant was George Sohier, who lived there until 1893. Later, in 1906, it belonged to Julia Hosmer (widow of Prescott Hosmer) and her nephew Edward Caiger.

On September 1, 1980, 25 acres of farmland in West Concord was legally converted to condominium property, to be called Concord Greene. The roadways are named after familiar apple species. The pool and clubhouse area for the complex had previously been a barn (built in 1875 and burned in 1972). The farmhouse is used now as an office. It was originally Hosmer land. It was then sold to William Brown and then to the Sheehans (Jerry and Ellen), who sold it to the Comeaus (Edward and Olivia). Comeau was a contractor. Among other things, he rebuilt both the North Bridge and Flint's Bridge. He died in 1955.

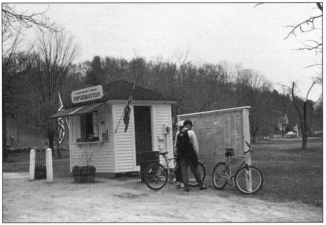

Concord's responsibility to visitors who come to see the town's historic sites has provoked a diversity of responses over the years. The small Concord Chamber of Commerce information booth, first located in the flagpole section of Monument Square, was moved to Heywood Meadow on June 1, 1967. It has been deemed not only inadequate for today's tourist crowd but also woefully uncomfortable for the volunteer information providers. Recently, the Middlesex Bank offered a corner of its land for a center to be built by 2002. It will include public bathrooms—an issue that has concerned the town for more than 100 years.

The old District 2, East Quarter, schoolhouse has served various purposes. Besides being a school, it has been a tool shed, a mortuary chapel, the site of Episcopal services, and the Sleepy Hollow Cemetery office. Tish (Patricia) Hopkins, cemetery department supervisor (pictured here), comes from a well-known Concord family. Her father, Donald, worked at the Light Plant for 36 years. Her grandfather was born here in 1895; her great-grandfather came from Galway as a young man and was married here at St. Bernard's. Hopkins's assistant is Stacy Paquette.

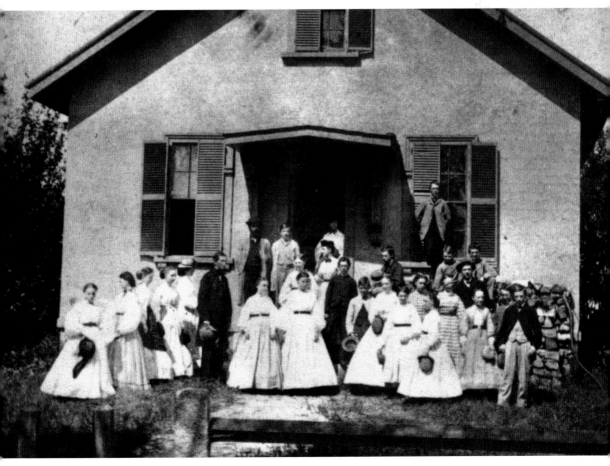

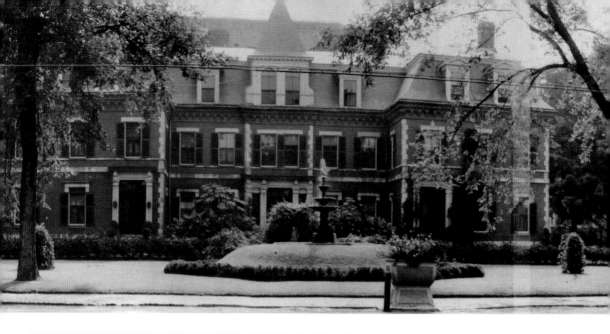

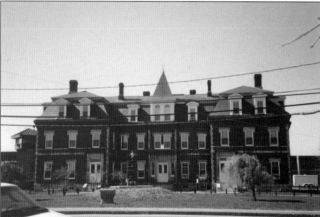

In 1892, when the Reformatory (now the Massachusetts Correctional Institution) had been running for eight years, the costs for maintaining 746 inmates were $179,190.14.

Col. Gardiner Tufts was the first superintendent. He was "an estimable Christian gentleman," who "gave his heart to the erring under his care and zealously labored to build up and maintain an institution affording the best means for their reformation." Reformation really meant education and vocational training. Seventy dozen shoes were made, 400–600 chairs (per day), and 3,000 trousers a month were made at the Reformatory. At the farm (100 acres), there were 80 cows, 8 horses, and between 400 and 800 pigs, yielding $4,975.57 in milk value and $2,997.67 value in pork.

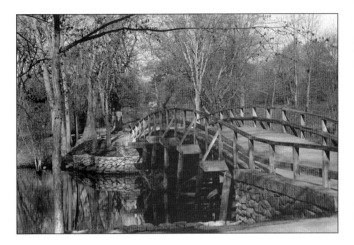

"We were soon floating past the first regular battle ground of the Revolution, resting on our oars between the still visible abutments of that 'North Bridge,' over which in April, 1775, rolled the first faint tide of that war, which ceased not, till, as we read on the stone on our right, it 'gave peace to these United States.'" So wrote Thoreau in *A Week on the Concord and Merrimack River*. The North Bridge has had many incarnations brought about by spring floods. Recent construction has made a stout and sturdy bridge, over which many tourists walk in silent surprise at their emotional response to the simple scene.

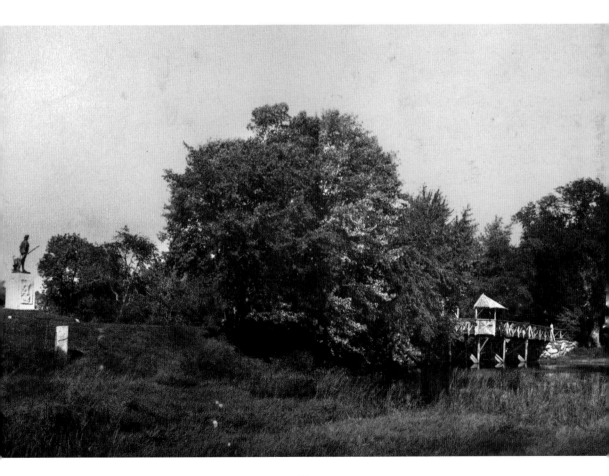

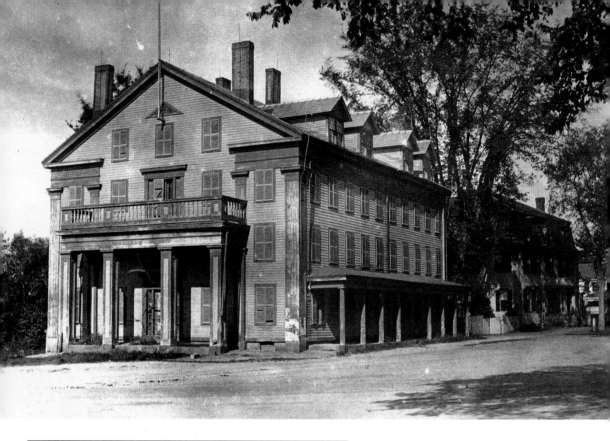

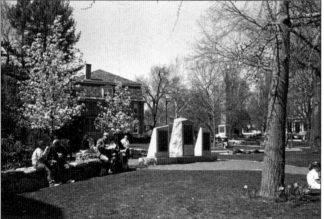

The site of the Middlesex Hotel was particularly handy for the out-of-town visitors who came to town for the court sessions in the early 1800s and who liked to feel the pulse of town affairs from the warmth of the barroom. It burned in 1845 and was rebuilt to last another 45 years, albeit in steadily deteriorating circumstances. Finally, in 1900, Edward Emerson, Stedman Buttrick, Prescott Keyes, and Richard Barrett bought the old ruin for $6,650 and tore it down. The following year, the town took the land for a park, reimbursing the men for what they paid for the hotel. Everyone was happy. The three-monument memorial addition to the park, with its stone benches, is an attractive meditative corner easily accessible to the townspeople, as well as to interested tourists who wish to remember those who gave their lives in recent wars.

Martha's Point, overlooking Fairhaven Bay, is described by George Bartlett as "where the rare milk weed grows, and the Fall picnics fill the air with the steam of boiling corn and roasting potatoes, Fairhaven bay gradually widens out into a great lake, covering an area of over seventy acres." William Brewster saw yellow-rumped and yellow palm warblers on the point on May 3, 1892. "It was a great bird day; the country was simply swarming with migrants and there was much song at all hours." On April 23, 2001, yellow-rumped and pine warblers were observed on the island in Fairhaven Bay, just upriver from Martha's Point.

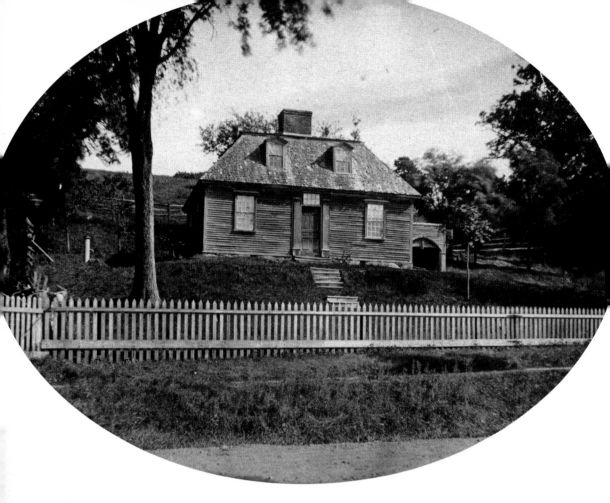

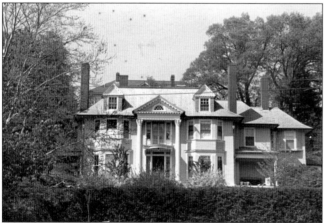

George Minot's house was diagonally across the road from the Emersons. It had been moved there from a spot east of the Orchard House by Abel Prescott, George Minot's grandfather. It was burned and then razed in 1898, making room for the Sellors mansion, built by Fred W. Sellors at the end of the 19th century. He was the founder of FWB Sellors & Company, which made "gents' furnishings:" umbrellas, valises, and the like. His wife was the former Edith Heywood, daughter of George Heywood. Sellors died in 1901 at age 38. His daughter Edith continued to live in the familiar landmark until her death in 1983.

Even though the road has changed, River Cottage on Liberty Street has a fine view of the significant action celebrated every year at dawn on April 19. The house was built *c.* 1845, although the original roadway, Liberty Street, was not named until 1873. Simon Brown (1802–1873)—editor of *The New England Farmer* (1851–1873), advocate for the farmers, and, ultimately, first the clerk and then librarian of the U.S. House of Representatives—was the most prominent early occupant of the small chalet-like, Gothic Revival house. Daniel Chester French's plaster frieze of Grecian figures (similar to the one in his studio) adorns the mantel.

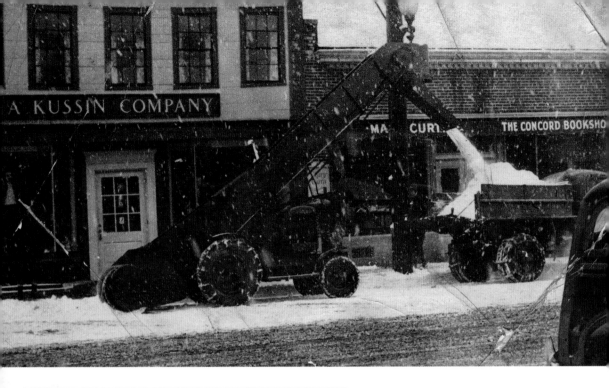

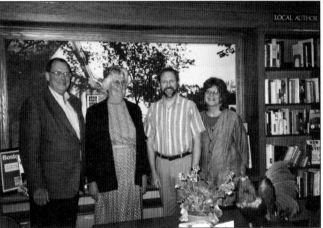

The Concord Bookshop has established the town's image as a literate neighborhood as certainly as the famous authors' houses, their gravesites, and their historic monuments. Since 1940, the bookshop has reflected, in unusually creative ways, the taste and temper of the reading community. Customer satisfaction has always been at the forefront of the minds of the proprietors, whether it is books or a lending library, greeting cards, newspapers, book searches, afternoon tea, browsing, or book-signing events. The original owners, Joan Baldwin and Fidie Warren, retired in the 1960s. The bookshop is currently owned by members of the Morgan Smith, George Kidder, and Henry Laughlin families. Pictured here, from left to right, are Kim and Belinda Smith, Dale Szczeblowski, and Carol Stoltz.

Walden Pond was formed by the glacier and is, in places, 100 feet deep. There is no apparent inlet or outlet, so all the water is runoff or direct accumulation from rain or snow. In 1922, abutters gave 83.4 acres to the state. The state gave management responsibility to the county. It was the county that built the bathhouses and otherwise developed the pond into a tourist attraction. In 1965, the pond became a registered National Historic Landmark. Walden Forever Wild, an organization founded in 1980 by Mary Sherwood (the first woman forester), sought to protect the pond's fragile environment.

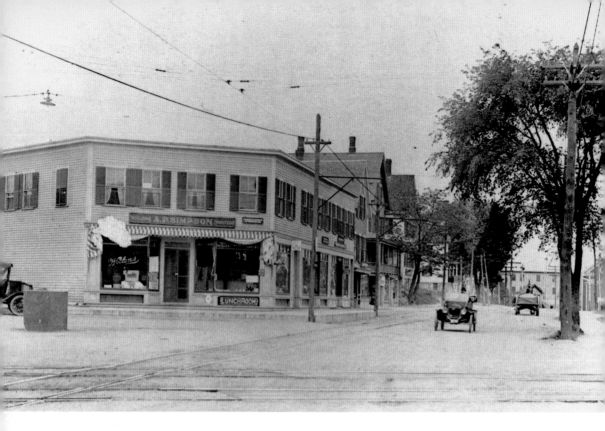

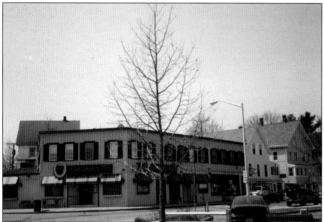

The 99 Restaurant is on the site of the junction of the Fitchburg (Boston & Maine) (1844), the Framingham–Lowell branch of the Old Colony (1872), and the New York, New Hampshire & Hartford Railroads. John F. Kennedy's grandfather John "Honey Fitz" Fitzgerald, who lived in the Simpson house on Main Street from 1897 to 1903, took the train to Washington from the junction when he was a congressman. During World War I, the Harness Shop shipped 400 artillery harnesses for Russian, British, and U.S. forces. Prior to the railroad, from 1830 to 1832, the District 4 school was on the site. It was moved in 1832 and again in 1875 and renamed Westvale Primary School.

The barn at the Derby farm in West Concord was built in 1794, 169 years after the Derby family (pronounced Darby) built the first bridge across the Assabet River to West Concord. The barn was torn down in 1874. In 1900, the land known as the Derby Addition was sold to create the housing developments on West, Central, and Highland Streets, but, in fact, the Derby land extended far beyond that. Dean and Charlie Comeau constructed the West Concord Mall, built on the site of the Derby farmhouse and barn in 1969. Long-term businesses there include the White Hen Pantry, the Middlesex Bank branch, and the West Concord Pharmacy.

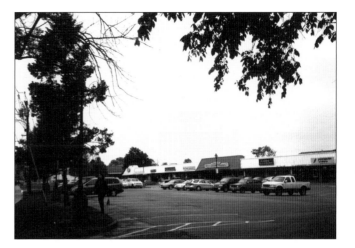

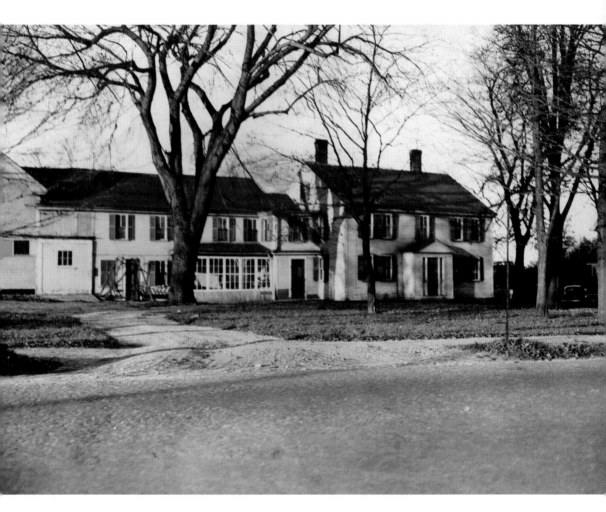

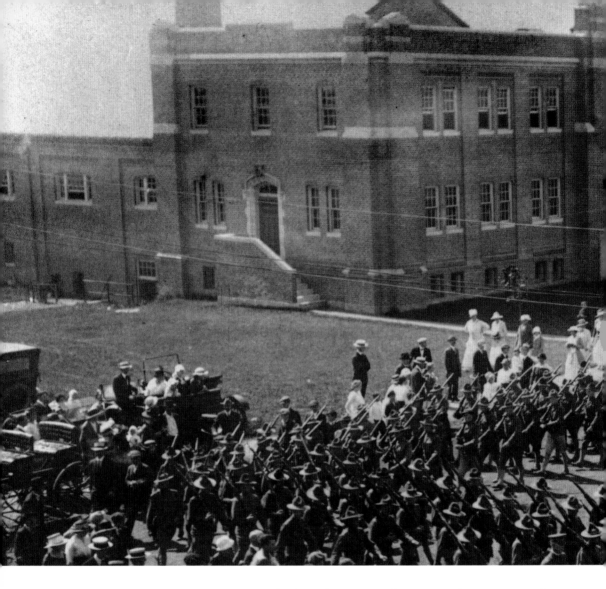

In 1914, the State of Massachusetts bought land on the corner of Everett and Stow Streets for a new armory. The Company I, 6th Regiment of Infantry MVM, previously located at the old armory on Walden Street, made available "a suitable armory for the purpose of drill, and for the safe keeping of arms, equipments, uniforms, and other military property furnished by the state." The new state armory was dedicated on November 17, 1915. It was the first Colonial-style armory in the state—all others were "fortress types."

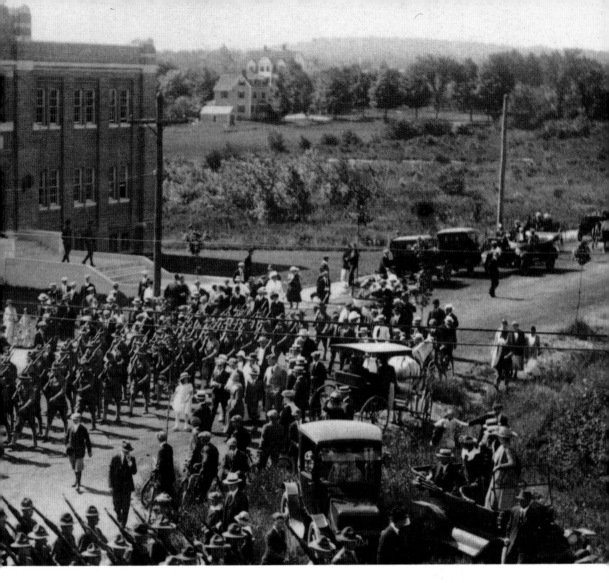

The Bigelow house was a refuge for a man nicknamed "Shadrach," who was the first slave to be presented for trial under the Fugitive Slave Law. The trial was interrupted by a posse who abducted Shadrach and transported him out of Boston as far as Concord. "Mr. Bigelow, the Blacksmith," as he was always called, sat on the jury when Elizur Wright, an abolitionist and one of the posse, was tried. Richard H. Dana was counsel for Wright. Horace Mann spoke eloquently about the inequity of the Fugitive Slave Law and the corruption of the commissioners who sustained it. Wright was set free. The Bigelow house remained in the family through the 1880s, perhaps longer. It was later owned by Charles Nutter and afterwards the Misses Metcalf.

An auction was advertised in the *Concord Enterprise* stating that John A. Finigan would have one of his famous "grand auction sales" of 24 horses ("good and sound") at the Derby land on Hubbard Street, on April 16, 1906. An early horse auction is recorded by the Reverend Ripley in his *History of the Fight at Concord*. He wrote that British Major Pitcairn was captured, disarmed, and his horse was taken to Concord, where it was sold at auction. Robert Gross believes it was given to the Reverend Emerson by the provincial congress. (Photograph courtesy of John Finigan.)

Chapter 3

THE

ACTIVITIES

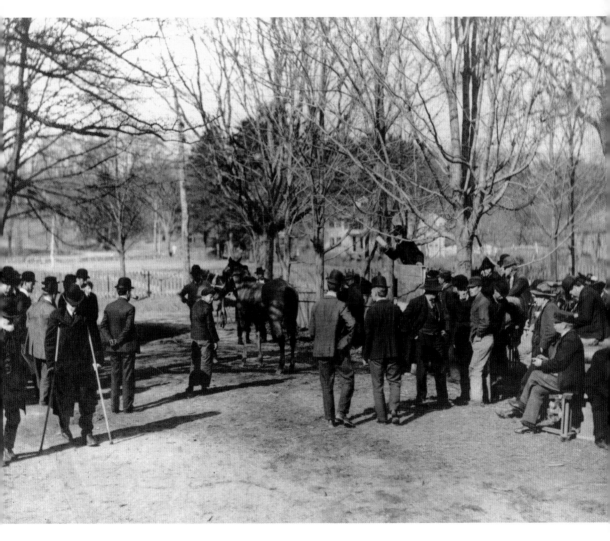

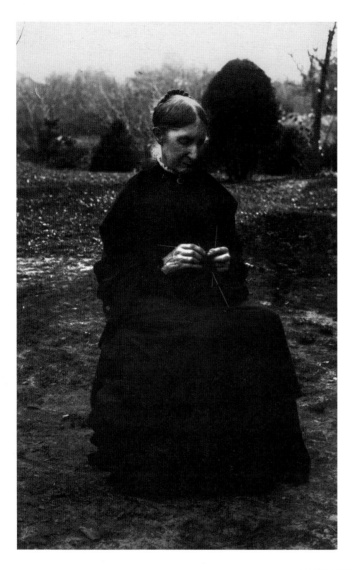

Knitting has always been a necessary activity of Concord women, especially at the Concord Town Meeting. Pictured below, Barbara Anthony keeps her fingers busy while listening attentively to the discussions. Years ago (according to Edward Jarvis), since socks were not worn until 1840, "leggings knit of woolen yarn like stockings with the lower part made to cover the upper part of the foot, with a strap to go under the foot . . . were drawn over the shoe and reached up the leg, generally to the knee, where they were bound by a garter. They were good protection against dry snow and the cold air, but not against water." Wool was always washed in hot soapsuds and allowed to dry without rinsing.

Horses have always been part of Concordians' work and leisure life. In 1875, there were 409 horses in town; 20 years later, there were 746. Horse racing was a popular pastime. In 1889, at the Cattle Show grounds, the racetrack was renovated, and trotting races were popular at the Driving Park. The Old North Bridge Hounds, named by Mrs. John Buttrick, was founded in July 1969 by Laurence Clark, Seymour DiMare, Carl Hazen, William Wright, Pat Cross, Ollie Lawrence, Mardi Perry, Sukey Smith, Margaret O'Brien, and Elsie Wright. The kennels were located at the Wright Farm on Barretts Mill Road. Registered hunt status was achieved in May 1971.

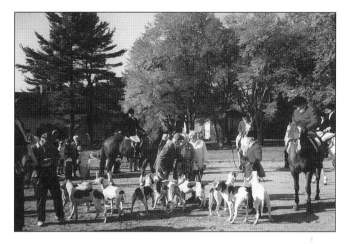

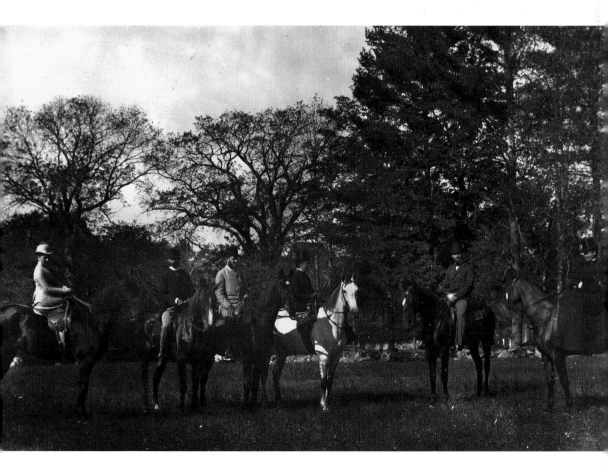

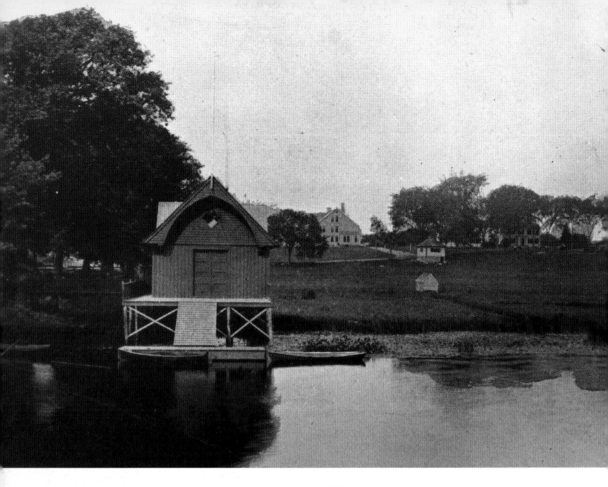

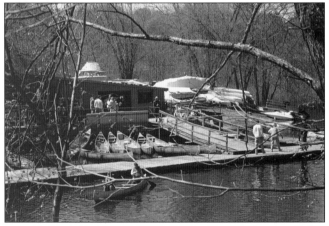

In its earliest days, the boathouse at the South Bridge was part of the property of James Garland's Concord Home School on Wood Street. Its original construction may have been designed by the architects Peabody and Stearns, who designed other buildings for the school in the 1890s. Subsequent owners have been Arthur Hosmer, Earl and Annette York, and John and Elsie Kennedy. The present owners, George and Shirley Rohan, have operated the business since the 1940s. The boathouse is one of Concord's best-known tourist attractions from early spring to late fall, serving canoeists and kayakers of every ability level.

By 1889, baseball had become so popular that it was not unusual for 10,000 spectators to attend the games, so the selectmen agreed it was important to have a decent field. "Many young men and boys, interested in the game . . . urgently represented to the [Public Playground] Committee that inequalities in the ground in the part of the field designed for ball games made it impossible to play matches [at Emerson playground]." The contract for repairs was given to Charles Prescott, and improvements were made with a recommendation that thereafter it should be the responsibility of the Concord Board of Selectmen to oversee maintenance of the field. The Concord Public Works Grounds Division maintains the field now.

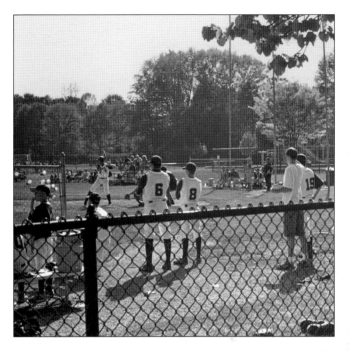

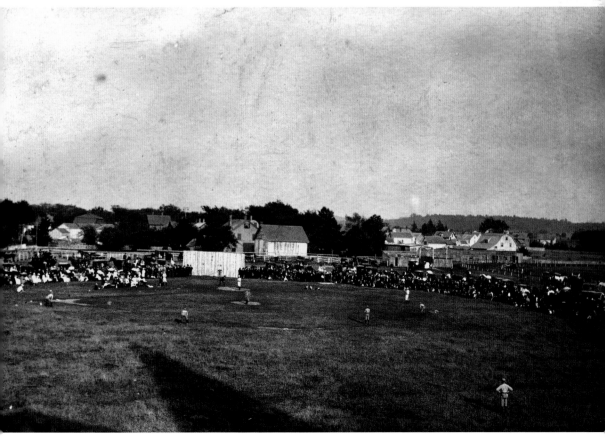

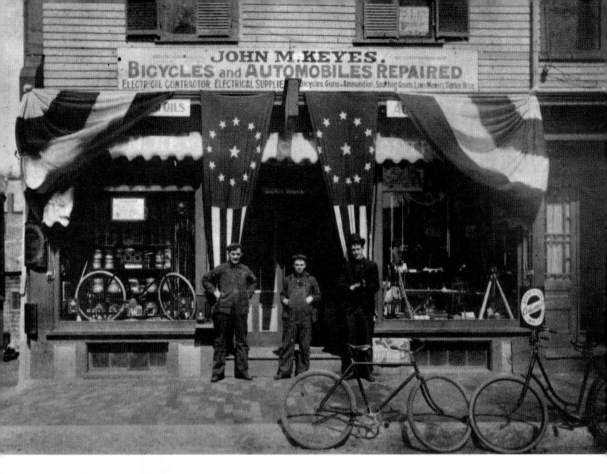

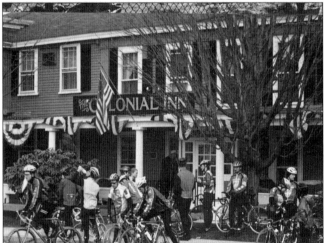

The bicycle has provided exercise both practical and pleasant for Concordians since the mid-1870s. Four thousand bikers arrived in Concord on April 19, 1896. In those days, one could be arrested and fined for riding on town sidewalks at a speed greater than 10 miles an hour. Nowadays, laws are being enacted giving cyclists equal rights with motorists on local roads. Biking is an increasingly popular alternative to commuting by car or train. Sporting goods stores (Smith, Wood & Keyes, John Haskell's, the Macone brothers, and, recently, John Carr) have supplied Concordians with quality machines as well as the varied and important accouterments to go with them.

The Concord Band began modestly as a marching band on April 19, 1959. Its first regular concerts started in 1961; William Tolman, the beloved band director, came a year later. He had received a master's degree in music at Boston University of Lowell and was manager of the District and All State Music Festivals of the Massachusetts Music Educators' Association. Although the band marched until 1970, its popularity soared when they organized as the Concord Band Association and gave outdoor concerts first at the library and then, after 1969, at the Buttrick Mansion. Nowadays, the band's concerts are an important part of the summer performance calendar at the Fruitland's Museum in Harvard.

GRAND PROMENADE
CONCERT!
—— BY THE ——
CONCORD BRASS BAND,
—— AT THE ——
TOWN HALL,
—— ON ——
Wednesday Ev'g, Sept. 6, 1871,

The proceeds arising from the sale of tickets to be appropriated for the benefit of their unfortunate member,

EPHRAIM W. BULL, Jr.

Who was so seriously injured by the premature explosion of a cannon on the 4th of July last.

PROGRAMME.

1. Remembrance of Paris. Quickstep.
2. Andante and Waltz.
3. Blondinette Polka.
4. Yankee Musical Jokes.
5. Home by the River. Quickstep.
6. Andante and Ferdinand Schottische.
7. Peri Waltz.
8. Galop.
9. On the Water.
10. Finale. National Airs.

DOORS OPEN AT 7.30, CONCERT COMMENCES AT 8 O'CLOCK.

Admission, including Dancing, One Dollar.

☞ Tickets for sale at Whitcomb's Bookstore, and at the door.

Tolman & White, Steam Job Printers, 221 Washington Street, Boston.

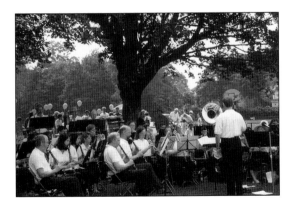

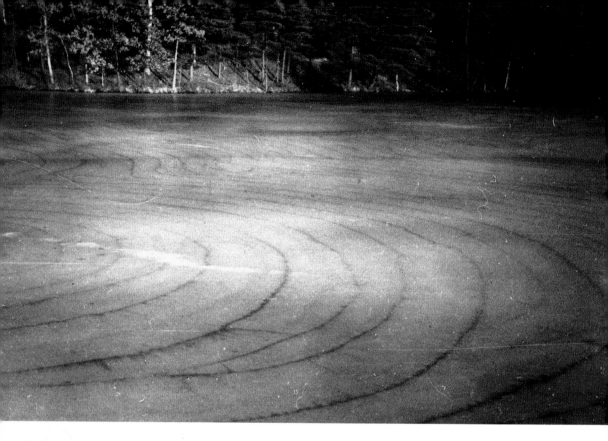

Fairyland! Nobody knows for sure why it is called Fairyland. Some think it was named by the Emerson children, others by the town's children who had fairy theatricals there. Its formal name memorializes its purchaser, Hapgood Wright (1811–1896), who gave the 70 acres from Walden Street to Cambridge Turnpike to the town. The Concord Town Forest Committee, ultimately the central core of the Concord Natural Resources Commission, was formed to maintain the property as a recreational area. The photograph taken in January 1941 shows the waves—called a frozen seiche—created by the December 1940 earthquake.

One of Concord's most reliably colorful routine event is a parade: for Patriots Day on April 19; the town birthday on September 12; Memorial Day in May—all these are cause for a marching band or two, or three, invited military groups, community organizations, honored citizens, and, of course, the Minute Men. The townspeople turn out with loyal enthusiasm to show their civic pride and national respect. In the old days, Memorial Day was a day of remembrance and gratitude; it still is. This parade is a more private affair, the memories more personal, than on Patriots Day. The onlookers share the emotions of the moment, as may be seen during a performance of "The

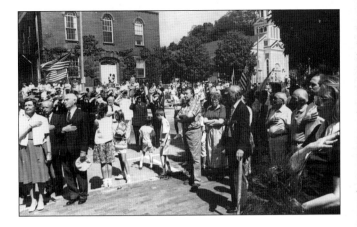

Star-Spangled Banner" in 1986. In 1902, the faces of the veterans reflect their own personal bereavement.

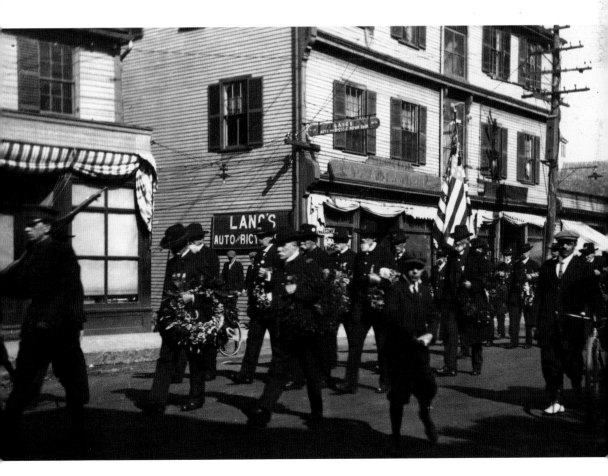

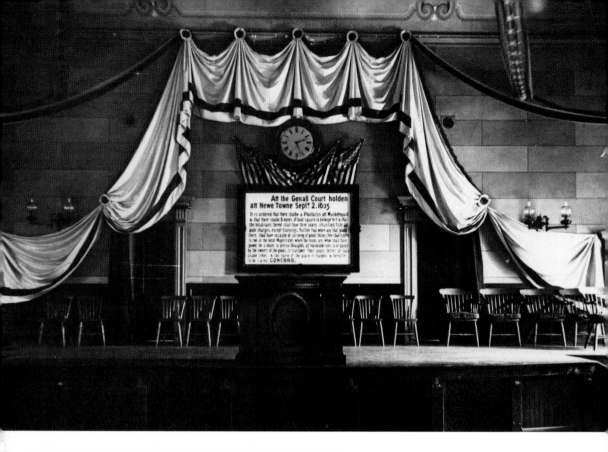

The assembly hall in the Concord Town House was a busy place in the old days. In 1890, for example, besides lectures, frequent concerts were held there. The Lyceum Vocal Concert was held on November 2, the Concord Choral Club on December 17, and the Lyceum Glee Club on December 19. Nowadays, chorus groups are similarly well received by the townspeople. There are chorus groups for women (the Colonial Spirit Chorus) and choruses for men. The Sounds of Concord: A Men's Barbershop Chorus was begun by Bob Long in 1970. Its directors have been (in addition to Long) Ray Taylor, Norm Buerklin, Dave Patterson, Brian O'Leary, Carl D'Angio, Greg Caetano, and Karen Rourke.

In the old days, there was a blacksmith with a forge who shoed the horses, made (among other things) andirons, and repaired wheels. A whitesmith worked with tin and galvanized iron. Today, there are farriers who shoe horses, welders who specialize in welding and fabrications, and tinsmiths, cabinetmakers, and carpenters who manage woodworking jobs. The detail of Stacy Tolman's blacksmith shown here, taken from a postcard, neatly exemplifies a modern-day craftsman, such as Ken Marriner, who has a well-equipped shop with a fine collection of tools for both wood and metal work and the skills to accomplish a wide range of repairs and reconstructions.

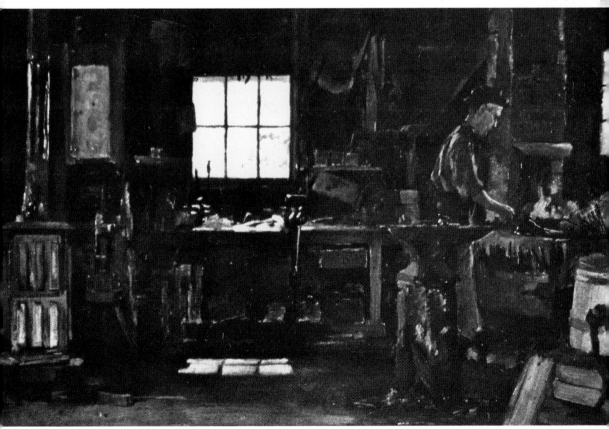

In 1998, Building Bridges—a program of the Greeley Foundation for Peace and Justice "with the mission of promoting social justice programs that unite people of different racial, economic, ethnic and religious backgrounds"—asked various town groups to create a sculpture, shaped somewhat like the London Bridge, on the Concord Free Public Library lawn. It was made of 25-inch cubes (pictured here), decorated on three sides to express "urban-suburban social justice" in the community. In the past, the library lawn framed the elegant building and gave the intersection of Sudbury Road and Main Street a space in which people could meet together in an atmosphere of urban-suburban style and tranquillity.

In 1913, Leif Nashe came from
Norway to live in Concord. He was
a skier from earliest childhood. He and
his friends Becky Dunning (shown
here) and Nick Jacobson went over the
ski jump on Nashawtuc Hill holding
hands, demonstrating their ability to
manage their skis safely despite utterly
inadequate bindings. Skiing had become
a recognized sport in 1876, but it was
not until 1890 that Peter Severinsen
began making skis in Concord, and
not until 1930 that skiing acquired
popularity. Nashe and his friends'
daring skills may be compared with
modern skateboarders in gymnastic
competence, but today's acrobats lack
the facilities to perfect and refine their
feats.

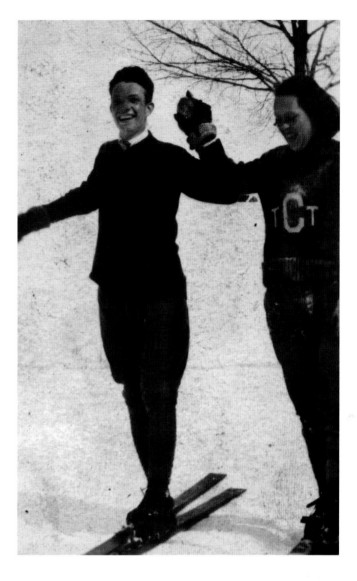

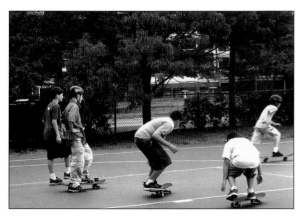

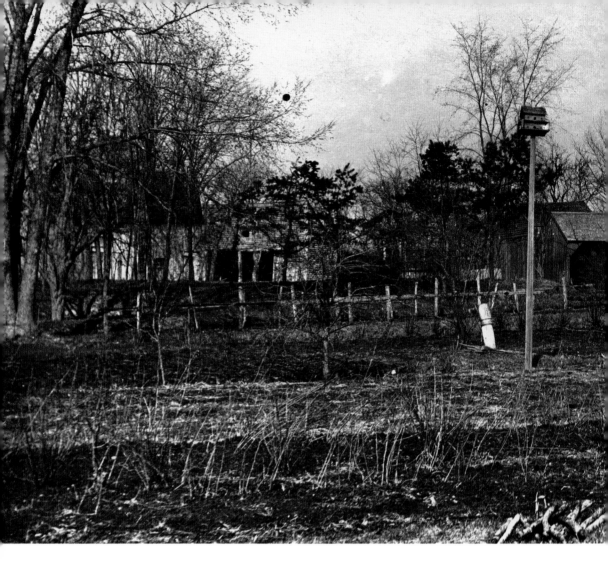

For more than 30 years, the Old Manse garden's historic authenticity was preserved by Mary Gail Fenn. Now the garden, described as a "colonial reproduction garden," is one of two spots in Concord (the other is at Thoreau's birthplace on Virginia Road) where the volunteer operation known as Gaining Ground maintains acreage for the cultivation of organic produce to be delivered in the Boston area to food distribution programs and shelters—among them the Concord Open Table, Food for Free in Cambridge, Project SOUP and the Walnut Street Center in Somerville, and the Cameron Senior Center in Westford.

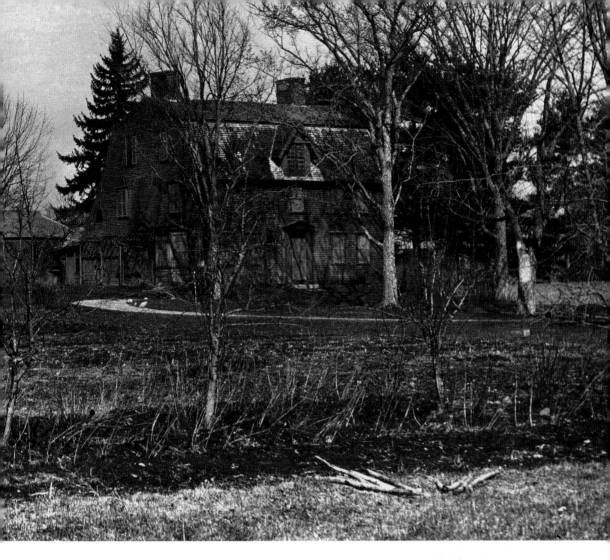

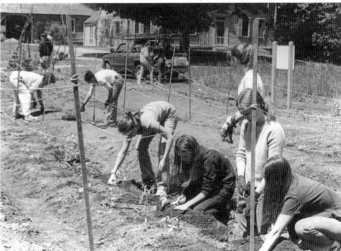

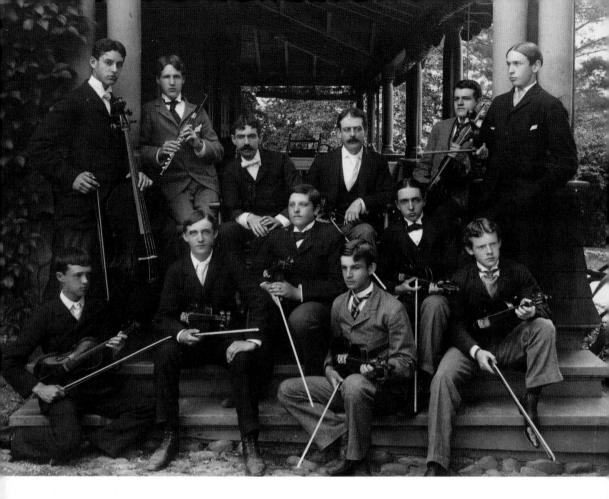

Although there were small orchestras in Concord—perhaps the most memorable was Thomas Surette's string orchestra in the 1920s—the Concord Orchestra had no direct descendants. It was organized in 1953 and began with 16 members. By 1954, it had grown to 40 members. The first rehearsals were held at the Fenn School, and concerts were given at the junior high school (what is now the Emerson Umbrella). Later (1966), rehearsals took place at the Concord-Carlisle High School and then, finally (1974), at 51 Walden Street. There have been five conductors: George Brown, Colin Slim, Dr. Mallow Miller, Attillio Poto, and Richard Pittman. Concerts were free until 1957. The String Orchestra, shown here, was one of the vehicles by means of which Curette taught teachers and produced "a philosophic, psychological, musico-anatomical understanding of the compositions themselves."

Hugh Cargill (d. 1799) was a British soldier who changed sides and prospered in his adopted country. His farm became the town poor farm in 1800 (until 1945). In the 1920s, part of the farm was used by the Concord Public Works. Since 1991, the Community Garden acreage, managed by the Concord Natural Resources Commission, which was part of the original Cargill estate, has been available for "anyone, rich or poor" who wants to grow a garden in the sun, in fine garden soil without chemicals or herbicides. The rent money for the garden plots goes to the Hugh Cargill Fund. The fire station, police station, and the Alcott School are all on land formerly part of the Hugh Cargill farm.

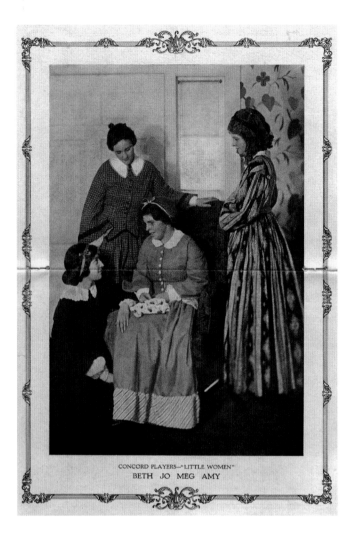

CONCORD PLAYERS—"LITTLE WOMEN"
BETH JO MEG AMY

The Concord Players have entertained townspeople since 1919. Every 10 years, they restage *Little Women,* in which familiar performers over the years have been Dorothy Arnold, Nancy Baldwin, Chris Davies, Roger Fenn, Peter Hugens, Anne Jewell, Louisa Alcott Kussin, and Hans Miller. Recently, the Concord Players staged *Jacques Brel is Alive and Well and Living in Paris,* which in 2000 won the Best Production award at the Eastern Massachusetts Association of Community Theatres Festival. This year, the production is representing New England at the National Festival. In the photograph below are director Kirsten Gould, music director Susan Minor, stage manager John Murtagh, and cast members Lewis Blair, Carissa Burkhart, Shana Dirik, Tom Dinger, and Larry Peterson.

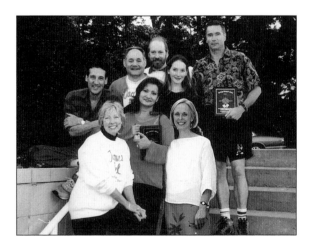

Lorenzo Eaton learned the cabinetmaking trade from James Adams (*c.* 1798–1863) in the 1830s. He married Harriet Pratt, daughter of Alvan and Sarah Pratt. This pictured advertisement appeared nine days before her death on May 2, 1841. Their daughter Amelia married Frank S. Wheeler. Besides his association with the Middlesex Institution for Savings and the Middlesex Fire Insurance Company, Eaton was an original member of the B[illiards] C[hess] & W[hist] Club. Bill Brace carries on the Concordian craft of woodworking. According to his brochure, he "designs and builds handcrafted furniture [tables, chairs, desks, and chests] in his own shop."

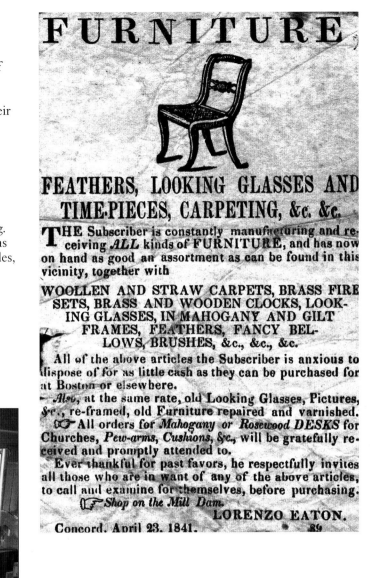

FURNITURE

FEATHERS, LOOKING GLASSES AND TIME-PIECES, CARPETING, &c. &c.

THE Subscriber is constantly manufacturing and receiving *ALL* kinds of FURNITURE, and has now on hand as good an assortment as can be found in this vicinity, together with

WOOLLEN AND STRAW CARPETS, BRASS FIRE SETS, BRASS AND WOODEN CLOCKS, LOOKING GLASSES, IN MAHOGANY AND GILT FRAMES, FEATHERS, FANCY BELLOWS, BRUSHES, &c., &c., &c.

All of the above articles the Subscriber is anxious to dispose of for as little cash as they can be purchased for at Boston or elsewhere.

Also, at the same rate, old Looking Glasses, Pictures, &c., re-framed, old Furniture repaired and varnished.

☞All orders for *Mahogany* or *Rosewood DESKS* for Churches, *Pew-arms, Cushions, &c.*, will be gratefully received and promptly attended to.

Ever thankful for past favors, he respectfully invites all those who are in want of any of the above articles, to call and examine for themselves, before purchasing.

☞*Shop on the Mill Dam.*

LORENZO EATON.

Concord, April 23, 1841. 89

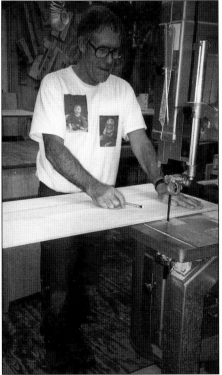

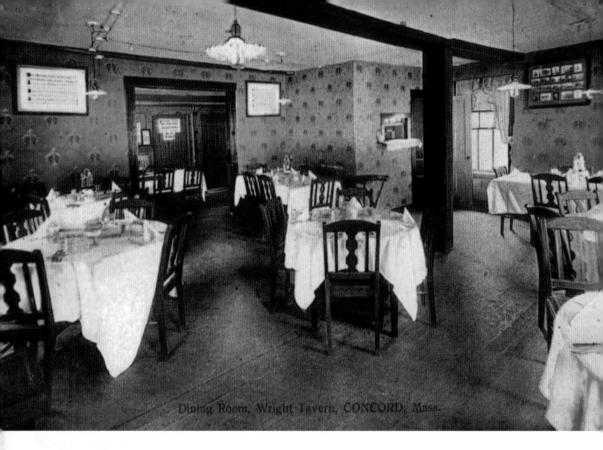

Dining Room, Wright Tavern, CONCORD, Mass.

The Wright Tavern, located in the center of Concord beside the First Parish Church, is most often remembered as the place where British soldiers stopped for refreshment and Major Pitcairn stirred his brandy with his bloody finger, but in the early 1900s travelers and townspeople could have a fancy dinner there in an atmosphere of style and refinement. The Willow Pond Kitchen on Lexington Road had no such pretensions. Before it was razed by the Minute Man National Historic Park it was a colorful roadside restaurant frequented by locals, as well as tourists, who enjoyed the hunting lodge décor and the menu of beer, lobsters, and french fries. (Photograph courtesy of Brad Bigham.)

Dances have been part of Concord's social life from very early days. Historian Edward Jarvis speaks of dancing parties at which a violin provided the music "for which each gentleman paid 25 cents." Ellen Emerson's "Germans" (social dances, primarily waltzes) were very popular, and, in the 1920s, the February *Bal Masque* featured 300 costumed dancers. Dancing for a charitable purpose was also a fairly frequent activity. Familiar faces photographed below are Ann (Chamberlin) Newbury (2nd from left), Elizabeth (Darling) Babcock (5th), Katharine (Howe) Edmonds (13th), and Alice Lowell (14th). They danced for the wounded French soldiers in World War I. Now, besides the Patriot's Day, police, and firemen's balls, there are folk dancing evenings at the Girl Scout House.

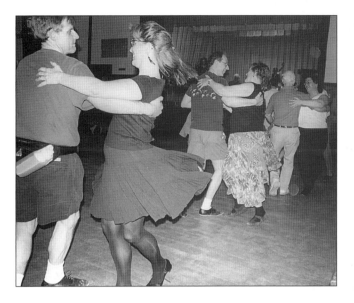

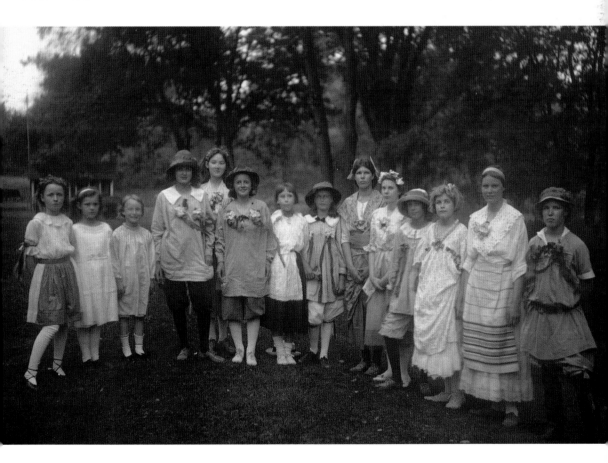

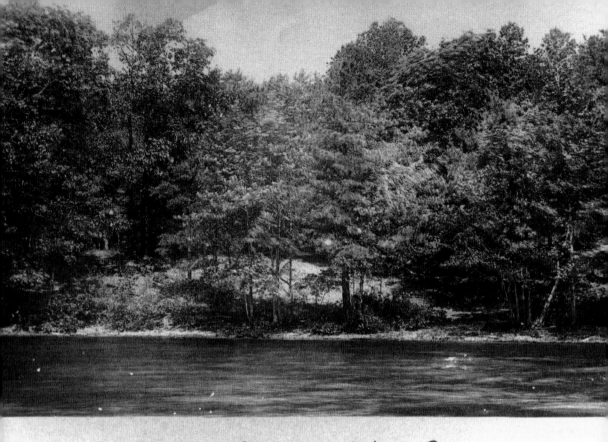

Thoreau Cove at Walden Pond

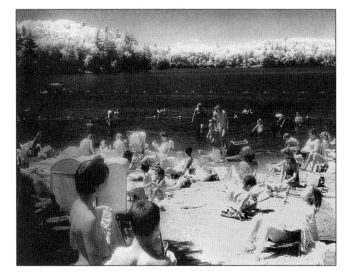

On a hot summer morning, the parking lot at Walden Pond is filled by 11 A.M. with people from the greater Boston area flocking to the pond to enjoy its natural beauty, cool clear water, and the ambient literary associations linked to it, little realizing that from 1866 to 1902 there was a railroad station at the far end, with an extensive amusement park and a large meeting hall where gatherings (often religious revivals) took place. Thoreau's cabin is also gone. "All, all have fled, Man [Thoreau], and cloud, and shed." Fortunately, the view from Thoreau's Cove so treasured by Thoreauvians is unchanged.

The 180-acre farm on the Old Road to Nine Acre Corner belonging to John Brown was sold to the Concord Country Club in 1913 for $20,000. (The club's property has since increased to 195 acres.) The farmhouse was moved to Emerson Hospital property in 1926, making space for the club parking lot. The barn became the clubhouse, and the icehouse became the greens superintendent's house. The brook was dammed to make a swimming hole. The Concord Country Club had various predecessors: one, surely the most famous, was on Nashawtuc Hill; another, perhaps the least famous, was on the site of the present Concord Public Works.

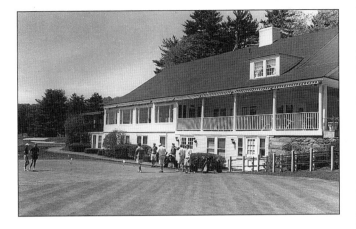

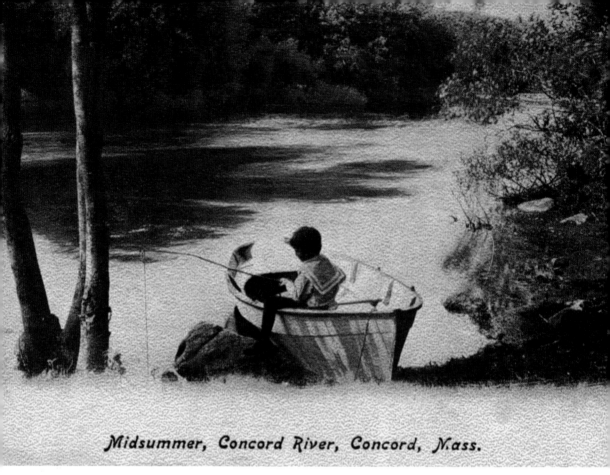

Midsummer, Concord River, Concord, Mass.

Children have always had fun in boats and have appreciated nature in their special way. The rivers (Sudbury, Assabet, and Concord) are, and always have been, an essential element in Concord's value system. Musketaquid Earth Day in Concord is celebrated yearly on the last Saturday in April. In 2001, the theme was Honoring Musketaquid Predators, particularly the fox, coyote, and fisher, recently seen in Concord, to the consternation and confusion of many residents for whom these animals are unfamiliar and therefore anxiety provoking. The river is the focal point of the festival.

The League of Women Voters of Concord and Carlisle was founded "to promote political responsibility and informed activity" by (as Katharine Kinkead wrote in the 1956 May *New Yorker*) "a resolute, intelligent band of opinion molders." Past presidents include familiar names of women whose contribution to Concord politics and town government is legendary: Sarah Goodwin, Eleanor Fenn, Louise Haldeman, Ruth Lauer, and Carolyn Davies. Recent concerns have been school budgets, youth and elder services, and affordable housing. In April 2001, decisions included support of the notion that Concord school budgets "should exceed the levy limit in order to serve the interest of the citizens."

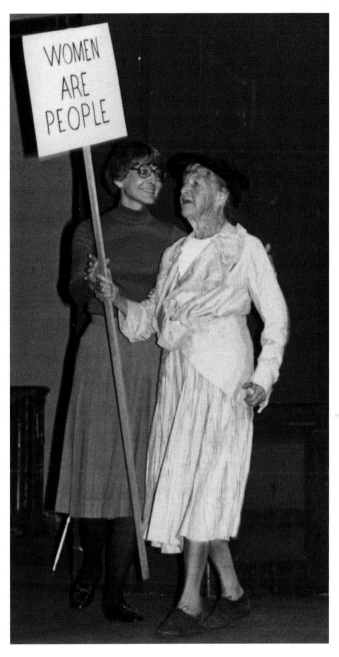

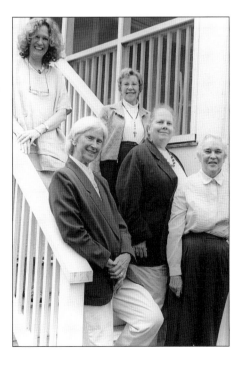

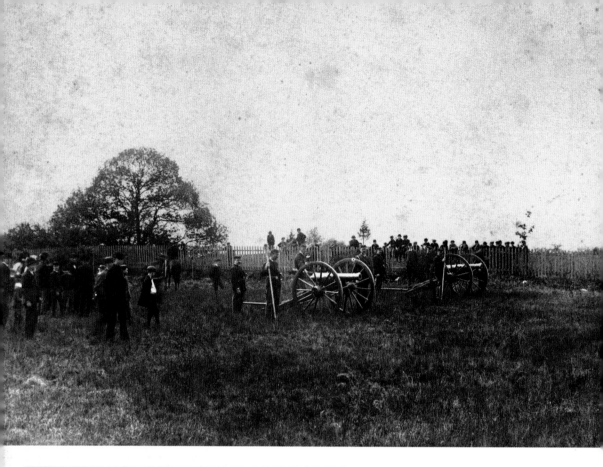

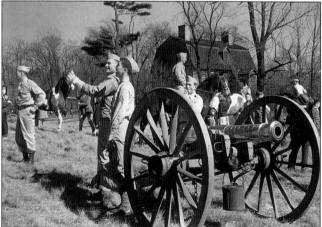

The Concord Independent Battery Association, formed in 1947, keeps its cannon at the gun house on Heywood Meadow. Its membership includes war veterans and gun enthusiasts. Concordians enjoy seeing them in the Patriot's Day and Memorial Day parades; dogs still tremble at the sound of the guns fired at dawn on April 19. In 1846, the Battery Association received new guns from the state (the old guns were put on view in the statehouse), which are inscribed by the state legislature in memory of Maj. John Buttrick and Capt. Isaac Davis, "whose valor and example excited their fellow-citizens to a successful resistance of a superior number of British troops at Concord Bridge."

The Concord Town Meeting traditionally begins with a moment of meditation to "consider that this annual town meeting is the means by which we and our neighbors endeavor to provide for our collective good." In the old days, the warrant was nailed to the elm tree in front of the Concord Town Hall. People dressed up in their best clothes to debate the articles that would set the advancements of the year to come—liquor licenses, repairing the bridges, the length of the sewer lines—whatever required the town's expenditure of money. The Concord Town Meeting is still a potent force in Concord. Voting is still a serious matter, and debate is still a formal undertaking.

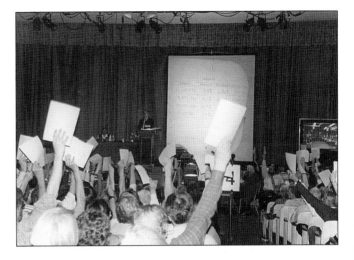

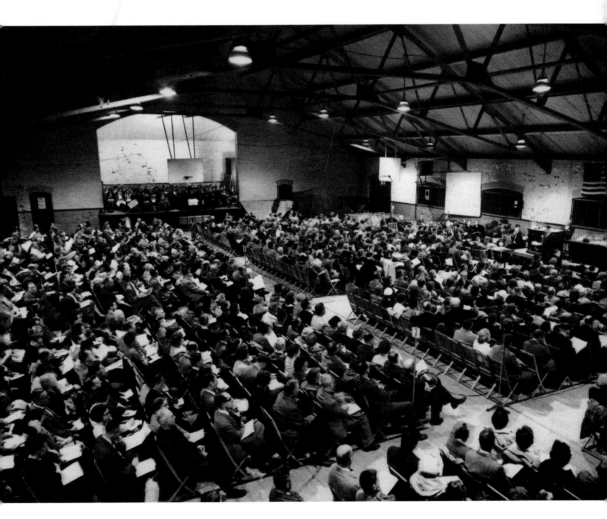

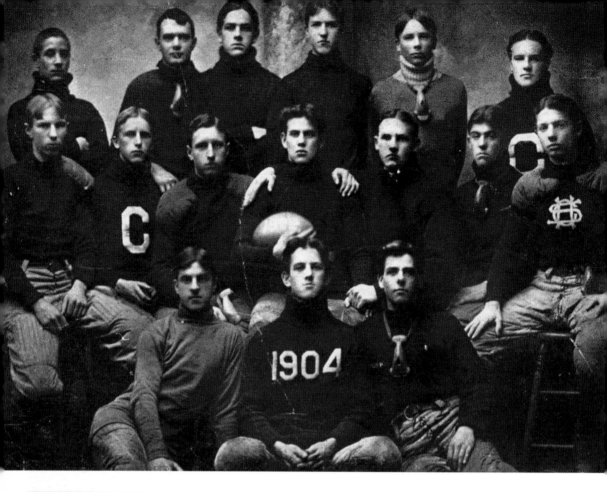

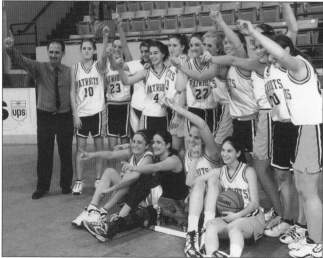

In 1860, Bronson Alcott wrote an eloquent defense of the virtue of exercise: "Teaching, preaching, pleading, trading, farming, house-keeping; hearth-sides, studies, the neighborhood, the landscape, are all of them the sweeter and the lovelier for [exercise]." In 1902, the Concord High School football team won the championship. Pictured from left to right are the following: (front row) J. O'Connell, J. Franks, and C. McKenna; (middle row) H. Hosmer, R. Emerson, R. Powers, H. Franks, H. Hatch, L. Cole, and R. Riefkohl; (back row) K. Keyes, H. Wheeler, J. Hanley, J. Eaton, G. Parks, and H. Ireland. In 2001, the Concord High School girls' basketball team won the state championship: Cristina Covucci, Katie Wayland, Erin Flynn, Kerry Flaherty, and Lisa Andrews.

Daniel Chester French built his studio, located in his father's apple orchard, in 1879. It was here that he produced the bust of Ralph Waldo Emerson, now in the Concord Free Public Library. Here, also, he may have worked on the statue of John Harvard, now in the Harvard Yard. When the rooms were open to the public—"a veritable old-time house warming. Such a goodly assemblage of wits and sages!"—it was possible to see the statues *Endymion* and *Echo,* as well as the Minute Man in its original plaster. The studio was 10 feet high, rising to 19 feet, and the tiling around the fireplace was, in French's own words, his "one set of fireside gods—his penates."

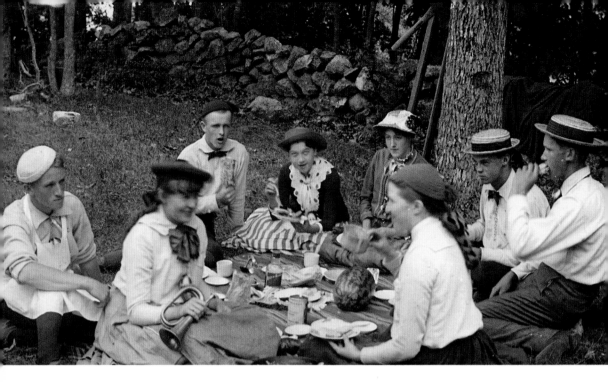

Picnics were a common pastime in Concord in the latter part of the 19th century. This group of young people whom Hosmer photographed may have belonged to one of the many clubs that sprang up at the time. For example, George Bartlett describes the Shakespeare Club, which met "in the summer vacation [when there were] pleasant picnics, for which original poems and other papers have been contributed by the members and their guests." The Concord Club, organized in 1880, had a clubhouse and liberal rules, which permitted female guests "to enjoy its attractions, and to profit by the opportunities it affords for rational and healthful recreation." During the workweek nowadays, townspeople often take their sandwiches and coffee to Monument Square, the Concord Free Public Library garden, or the Chamberlin Park between Keyes and Lowell Roads.